Hans-Erik Larsen

THE AESTHETICS
OF THE ELEMENTS

Imaginary morphologies in texts and paintings

A A R H U S U N I V E R S I T Y P R E S S

© Copyright Aarhus University Press, 1996

Translated by Kenneth Tindall
Graphic design by Jens Peter Tofte
Cover illustration: J. M. W. Turner: *The Angel standing in the Sun.* Tate Gallery.
Printed by The Alden Press, Oxford.
ISBN 87 7288 541 6

AARHUS UNIVERSITY PRESS
University of Aarhus
DK-8000 Aarhus C
Fax (+45) 86 19 84 33

73 Lime Walk
Headington, Oxford OX3 7AD
Fax (+44) 1865 750 079

Box 511
Oakville, Conn. 06779
Fax (+1) 203 945 9468

The publication of this volume was made possible by the support
of The Danish Research Councils and The Danish National Research Foundation.

∞
ANSI/NISO
Z39.48-1992

CONTENTS

FOREWORD

The four elements – air, water, fire and earth – are in these years claiming renewed interest within semiotics, as it now appears possible to examine them – that is to say, their representations in meaning formation – not as a kind of primitive physics or as a more or less complex reference to an intentional psychology, such as a hermeneutics to be studied in the metaphor. A kind of third path seems to be possible now in virtue of a renewed theory of the imaginary in human perception. The elements are examinable in this imaginary, not merely as preexisting elements of content but purely and simply as a background – a material dimension understood as dynamic and cognitive, both thymic and schematic morphologies of a lower order than complex metaphoric structures in the sentence. With the study of the elements in this third version there is question of a new *phenomenology of the imaginary*, which builds philosophically on the tradition of Maurice Merleau-Ponty, and methodologically on the catastrophe theorem of the mathematician René Thom.

This paper will advocate a hyperliteral theory that is propounded in two coherent parts. The first part, through five chapters, erects the theory step by step. The second part verifies the theory in a series of readings of aesthetic works and summarizes the entire theory.

In the first part the subject is located epistemologically: it is a question of aesthetically relevant meaning which is manifested in writing and pictorial art; the elements are placed as concrete realistic and aesthetic matter, which comes from a natural macrophysics and goes to a linguistic organization and vice versa. The element material is *produced in an imaginary hyperliteral* framework, which appears as a stratification into three mutual and coherent layers. These layers can be analysed topologically and dynamically, in that precisely the elements are shown as states connected with phase transitions.

The element material matter is analysed and reread through Maurice Merleau-Ponty's concept of phenomenological elements of content by which the world is appropriated, and it is endeavoured to enter into a dialogue with this phenomenology's isolation of prereflexive elements of content. From here on a line is run to Michel Serres, who emphatically points out the significance of tactility and topology for beauty and thought. Serres joins appearance and being (in a concept of the surface), an admission which to Merleau-Ponty was still separated, for example, in that philosopher's hypothesis of the elements as preexisting elements of content.

The next step is a discussion of two cognitive phenomenologies: a body-oriented and a structural cognition. In this "hard" phenomenology a preorganization of the

phenomenon of word class is defined, in which also the three imaginary worlds are placed in connection with three cognitive "worlds."

This hard phenomenology – hard in relation to a traditionally more "writing and intuitionalistic" phenomenology (Merleau-Ponty) – is continued via René Thom's dynamic topology with the cusp interpretation. René Thom's dynamics permits a new interpretation of the thymic and schematic morphologies in a control topology – organizing the element setting's thymic and schematic meaning. The elements are inserted, in other words, in a control topology, which is further grounded in an opposing of an excitation dimension and an ambivalence dimension as a constituent feature of beauty and thought.

This assembling of the elements' different morphological dimensions, an introductory, a philosophic, a cognitive and a dynamic assembling, is now thought as being the last and *most essential* segment in the three imaginary stratifications: a bio-imaginary world, a socio-imaginary world, and finally a phantasmatic or ideational world. In this section there are a number of renewed semiotic model universes further combined, a so-called G model and an A model, as propositions for the deciding argument: that the element material can be studied as *emotion*'s running through of thymic and schematic manifestation in the stratified imaginary.

In the second part, the technical phenomenology now reached is carried over into a number of analyses. Søren Kierkegaard's *"Ottevejskrogen"* (the Nook of the Eight Paths) is examined in textual closeup, and pointed out is the determining character of the place described and the element material for the sensing subject in the text. The Danish poet Thorkild Bjørnvig's *"Klitspejlet"* (The Dune Mirror) is followed in an even closer textual examination, in which a hyperliteral reading of the poem's element material follows the poem's emotional dynamics: from panic ecstasy to a calm bio-phantasmatic vision. With the painter J.M.W. Turner's *"The Angel standing in the Sun"* it is a question of diagrammizing through the picture of the dynamics of the gaze. The element material's both fluid and hovering matter functions as a dynamic foreground for the ecstatic and complex underlying phantasmatics: the nonportrayed God who is "shielded" by an angel. With the Swedish poet Arne Johnsson a temporal structure is inserted which seeks to explain a final excitation dimension of the elements opposite an ambivalent reality present. The excitation dimension with the "eloquent elements" is also unmistakable in the painter Edward Hopper's *"Solitude,"* which is also analysed in relation to the picture's event background, state background and field background. Finally, the analyses are concluded with the young Danish poet Simon Grotrian's complex self-referring poem *"Inspiration"*, which in the same way as with Hopper speaks through elements – only the reverse: where Hopper excites the picture as a running through from a *lower* ambivalent reality material and up into an upper dysphoric element material, in Grotrian there is a running through from an upper "thundering" element material down into a socio-imaginary ambivalence experienced as dismal. Final-

ly, the basis is summed up and the overriding point is contained in this paper's concluding words: that the elements are constructed as immanent regularities that repeat a *phenomenology of the emotions* in the aesthetic work and in the imaginary as such.

The present work falls within current Danish semiotics of the Aarhus school: the Center for Semiotic Research. It has though in front of it a number of questions: A first would be to concretize hard model formation – as model formation – which, so to speak, merely through the model formation and the latter's premises as formal description can additionally explain an older phenomenology's intuitionism. A universal description which can clear up Merleau-Ponty's dissociation between being and pre-being, and through the hard and imaginary dynamic analysis further treat the question of the elements as flesh (*la chair*), something between individual and world. Perhaps a bridge – a third bridge in relation to an intentional psychology, a naive physics. An imaginary third bridge which consists of universal elements and their morphologies.

Therein one might also study recent American and Danish cognitive preorganization and schematizing: how do the elements "behave" – for example – in relation to open and closed classes in a linguistic symbolized higher order?

Finally: this book is a pioneering work, likewise it is a revised version of the author's M.A. thesis for the "Institute of Comparative Literature," University of Copenhagen 1993.

This book is dedicated to the philosopher, semiotician and poet Per Aage Brandt, without whose tireless and intense interest, humour, labour and backing *nothing* was possible.

In addition I would like to thank Assistant Professor Jørgen Egebak, and The Writer's School in Copenhagen, which through a few years important for this work's genesis supplied invaluable learning and ways of reading – and along the way indirectly formed a discussion space for this writer. Thanks.

And a hearty thanks to theologian Kurt Abrahamsen, anthropologist Max Pedersen, and author Christina Hesselholdt. All of them have with wonderment, skepticism, and first and foremost an inestimable and present space of likemindedness, formed still another *elementary* background in an often complex alliance of hard work, emotional set-tos and other passions while this work was coming into being.

Finally, this work is also dedicated to my family and my parents, and last but not least to my daughter *Sara Elise* who contributed with drawings of wind, weather and other waves.

This book was translated by Kenneth Tindall and published with a grant from the Danish State Research Council for the Humanities – a gesture which injected the work with a last passage up into an excited space.

1. ELEMENTS AND MORPHOLOGIES

A theory of *the aesthetics and material of the elements* has no prominent place in comparative literature – nor in the other aesthetic lines. The elements – from the Latin *"elementum, elementa"* – *air, water, fire and earth* – as matter for themselves is either an overlooked or an over-and-done-with object of literary history, or else the question of the elements is relegated to being simply a part of the study of metaphor in the aesthetic object. This semiotic paper will endeavour in various ways to shed renewed light on the aesthetics of the elements.

In the present chapter, in approaching the analyses the aim is to isolate in a bird's-eye view some theoretical paradigms, some morphological explanatory bases, partly to introduce this work and partly to be able to define what can be conceived with a collocation of *elements and morphologies.*

This paper will, in different ways, pursue an objective depth level – such as in relation to a textual surface or a tactile pictorial surface. In other words, I will advocate the idea that the elements alone can't be said to be parts in a metaphoric-hermeneutic analysis, but rather that the elements are parts of an imaginary semantic formation and a cognitive perception. It will place this theory in a double stop: between, on one hand, being a theory of an imaginary subject's way of being *significant* and a cognitive subject's way of being *rational*, and on the other the paper will be a theory of *form* in the aesthetic expression.

Morphology occupies an extensive place in the humanities, now as stringently defined object in linguistics, as more or less gratuitous paradigm in a given analytical material. In classical Saussurian linguistics the distinction is made between morphology and syntax:

in that morphology looked after the study of the "word classes," that is, the discursive units which according to their size are words, and the syntax concerned itself with the latter's organization in the larger units, clauses or propositions and periods.[1]

This strictly semantic distinction between the word class level and the sentence level naturally also becomes a part of this analytics. Meanwhile, the aim is also to develop a theory of morphology, in such a way that it becomes possible to perceive the morphology as a form and a thymic value between form and "the world." And the morphology will in numerous ways be regarded as being a specific unity in a phenomenology – this connection will be shown in Chapter 2.

Fundamentally, the question of morphology will be perceived as a general consti-

1. Greimas, 1988, p. 157.

tuent, a "place" from which an imaginary semantic formation is generated. I will pose the question which Viggo Brøndal seems to be preoccupied with:

The systems which enter into a linguistic structure are – as we know – subject to rules which determine their construction and variation potential: rules which fall into the general morphology. These systems of words and forms must be imagined compounded of certain basic concepts that constitute the final level in the morphological analysis (...) The elements which are thus assumed to underlie any linguistic structure whatever and its constructions must necessarily be of an immensely general kind, inasmuch as they must serve for defining even the most abstract linguistic formations, morphological (classes, words, forms) as well as syntactical (sentences, parts).[2]

And Brøndal looks for general parts that assume: "the immutability and universal identity of discourse."[3] That will be this paper's parallel ambition.

A critique of such a position, in which morphology becomes a study of determining categories which form the basis for classes and sentences, in the hands of a Hjelmslevian position, for example, might read:

Classical morphology and syntax are not able to be maintained, inasmuch as "the whole" in advance of the parts given with the syntax, and the isolated pieces which separately should have fallen into place are grounded, for the sake of the whole, not in anything in advance of the sentence, and for that of the pieces not in a conception of the least parts of language.[4]

As it shall appear, this theory's laconic reply will be that in actual fact such if not wholes then preintentional forms and thymics do exist, from which meaning and surface result. This will be defended en route, and so we will leave this position in the above place.

This being the case, then, the question of morphology bears on the disciplines of the humanities, and it is my thesis that these disciplines can be described as being 1) grammatical, 2) semiotical, and finally 3) semiological.

Level 1) concerns the study of linguistic structure, 2) will concern the text as meaning, and 3) will concern a discursive cultural analysis. And one can say that 1) will also contain a cognitive level, 2) an aesthetic level, and finally 3) a hermeneutic level. This gives the following summary:

2. Brøndal, 1991, p. 34-35.

3. Ibid., p.35.

4. Rasmussen, 1992, p. 250.

1.	Grammar		Linguistic structure		Cognition
2.	Semiotics	\approx	Text	\approx	Aesthetics
3.	Semiology		Discourse		Hermeneutics

By the first level the description of the mode of existence and functioning of natural language is understood. Theory-historically this has been taken up by linguistics as its domain – such as by F. de Saussure.

This grammatical plane is in many ways a hybrid quantity while simultaneously it constitutes an absolute foundation for structural linguistics, for example, just as it is a scientific theoretical foundation for recent cognitive investigation – including at Per Aage Brandt's Center for Semiotic Research and within the new "cognitive science," one of whose main centers is in the United States with researchers like Leonard Talmy, George Lakoff and Mark Johnson. As a general statement, the study of morphology and syntax reside on this level.

The third level is an extensive elaboration of the grammatical-linguistic level, as represented by a principal figure like semiologist Roland Barthes. I shall not go into the details of this semiology, only point out that this study of "the life of signs in the life of society" becomes in principle a connotative and hermeneutic strategy; structures like fashion, advertising, saluting the flag, stratification of the text in codes, and so forth, are extralinguistic and also morphological-hermeneutic strategies, only here morphology is dependent on a historical discursive foundation, just like the analytical object focuses on a connection between text and reporter.

The semiotics which this theory takes part in turns up in level 2; it finds its object between the grammatical-cognitive dimension and the semiological-hermeneutic dimension.

The theory will argue for a realism in relation to the text (here the elements as an actually existing part of the macrophysics in the aesthetic object's semantics); this gives this theory a domain which approaches the semiological-hermeneutic position.

But this "operative" realism will at the same time acknowledge a pre-intentional imaginary and cognitive base, which moves this realism into a subject's general attitude to the world, just as this attitude is again asserted to be a part of a series of general and immaterial conditions in the form and in the aesthetics.

Therefore the question of the morphology will be analyzed in relation to two explanation bases: one in a theory of the cognitive (cf. Chapter 3), the other – and the paper's concluding argument – in a theory of the imaginary (cf. Chapter 5).

In the chapter about the imaginary one finds three stratifications, which all – in different ways – become significant semantics in the aesthetic form as well as in a perception of the world as such. One stratum is a so-called *socio-imaginary semantics*; it can be described briefly as a plane in the subject which refers to a concrete common

and experiential world; in it are found the "agreements," the "projects" and the communications between people. Here is where we regard the imaginary field we have before our eyes in everyday life. The second stratum in the imaginary stratification of worlds is the *bio-imaginary;* here is found an individual world of experience. The simple bio-imaginary is based on simple perceptions of the world as consisting of objects which can be normative and ambivalent: good or bad, large or small. The bio-imaginary is based on an experience of the body. And, finally, there is at length the question of a *phantasmatic-imaginary;* in it is the subject's notions about the other person, the erotic life, the life of the imagination, the world of dreams, daydreams and thought.

In various ways these worlds are all oriented according to *euphoric and dysphoric* values. These values comprise the most elementary morphological level in this theory. We are speaking of basic emotional attitudes to the world. In the dynamic interpretation (cf. Chapter 4), which appears as formal "strategy," these thymic values will be morphological attractors, the one (euphoria) characterized by a positive significance attribution in the subject, and the other by a negative significance attribution. These values hereafter attract other morphologies or formal values which can be regarded as *schemas,* that is, determining spatial categories and forms; for instance, euphoria attracts "nearness" and dysphoria "distance." It can be schematized thus:

$$\frac{\text{euphoria}}{\text{dysphoria}} \approxeq \frac{\text{nearness}}{\text{distance}}$$

And the above is, as said, morphological basic attitudes. These paradigms constitute the at once complex and simple "hardware" in this theory; the thesis is that these basic attitudes determine the semantic worlds in the imaginary as such. In other words, this theory asserts that meaning *arises through emotional values and schematic values.*

The cognitive inspiration will, naturally enough, be connected with the imaginary semantics – in the manner that a subject "cognitizes" the world through the imaginary semantics. The cognitive concerns the way in which a subject thinks. The work here will be on a syntactical level, alternatively with a theory of conceptual and syntactic-semantic structure. Also, the cognitive frame must be thought of in stratifications (cf. Chapter 3), here worlds (W for "world"):

W1	Perception		States		Nominals
W2	Communication	\approxeq	Events	\approxeq	Verbs
W3	Imagination		Fields		Adjectives

The main thing here is to argue for a schematizing of a subject which contains schemas for "states" (perceptions of the substances' macrophysics), recognizable and equivalent to the syntax's uses of nouns; schemas for events, recognizable and equivalent to the verbs' actions; schemas for imaginations and notions of something, recognizable and equivalent to the adjectives' emotional references. The cognitive side of the theory will constitute a background – but it is not a question here of a directly communicable instance as far as the schematic and conceptual background is concerned. Meanwhile, this conceptual background is manifested in the syntax, with which it becomes recognizable through the word classes. The thesis is furthermore that W1-2-3 can be thought together with, respectively, "the bio-imaginary," "the socio-imaginary," and "the phantasmatic-imaginary."

In the area between these levels is the concrete aesthetic expression. This is where the question of the elements comes in.

The elements will be regarded as concrete, realistic and substantial aesthetic materials; just as they are real macrophysical representations of the natural world. That is one of the theses.

The next thesis is that this element material rests on the morphological basic attitude to the world. The "near" hydrological element (water) is euphoric, the "distant" pyrological element (fire or air) is dysphoric.

But not only that: in the aesthetic expression we view doublings of the elementary thymic meaning attribution, so that there appears a paradigm like: "the solid" versus "the fluid," or "the dense" versus "the diffuse" – herein is also found this theory's first point of departure and question: how does the horizontal, corresponding naturally to the hydrological, relate to the vertical, corresponding naturally to the pyrological?[5]

In summary, the above introduction gives the following movement in the book:

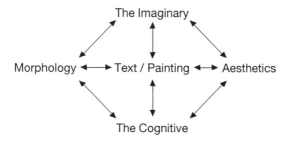

The Imaginary

Morphology ←→ Text / Painting ←→ Aesthetics

The Cognitive

And the morphology constitutes, as said, an objective, general basic attitude which is recognized in the expression (the text and the painting) and in the aesthetics of which the expression is a part. The expression becomes meaning in the imaginary semantics, in which the morphological, general level is regarded as thymic values and general schematas.

5. Brandt, 1989, p. 24-27.

The lower cognitive level henceforth constitutes the material, the schematic manner in which all of it becomes possible as meaning whatever.

A meaning formation which also functions as an element of content, understood as a further processing of Merleau-Ponty's and Michel Serres' phenomenology.

2. PHENOMENOLOGY AND MORPHOLOGY

With a starting point in phenomenological thinking three things are suggested: in the first place, phenomenological thinking is a part of this work; in the second place, phenomenology, as we shall be working with it here, is a direct discursive context on which "cognitive science" works further, and therefore a necessary foundation for the subsequent chapter; in the third place, there exists in connection with phenomenology a potential development of the morphologies.

Briefly and to the point, an outline for a discussion of phenomenological thinking is necessary, while simultaneously such an outline admits for a renewed reading of, in particular, Maurice Merleau-Ponty's works, inasmuch as it here is a question of enunciating this philosopher's scattered but important observations on the elements' role in phenomenological thinking.

A Merleau-Pontian phenomenology is the study of essences, and this is to be understood as the difficult manoeuver to distinguish between what in a philosophical context is defined as real essence and nominal essence.

This kind of phenomenology assumes that the world is a realistic facticity which is always already given before reflection as an unavoidable presence, while simultaneously this presence is converted into a vision, for example, which becomes a mental act – and an imaginary intentionality. This double stop between realism and nominalism is described in the famous introductory chapter *"Avant-Propos"* to *Phénoménologie de la Perception* (The Phenomenology of Perception), with the question "Qu'est-ce que la phénoménologie?" (What is phenomenology?):

It is a matter of describing, not of explaining or analyzing. Husserl's first directive to phenomenology, in its early stages, to be a 'descriptive psychology,' or to return to the 'things themselves,' is from the start a foreswearing of science. I am not the outcome or the meeting-point of numerous causal agencies which determine my bodily or psychological make-up. I cannot conceive myself as nothing but a bit of the world, a mere object of biological, psychological or sociological investigation. I cannot shut myself up within the realm of science. All my knowledge of the world, even my scientific knowledge, is gained from my own particular point of view, or from some experience of the world without which the symbols of science would be meaningless (...) To return to things themselves is to return to that world which precedes knowledge, of which knowledge always *speaks,* and in relation to which every scientific schematization is an abstract and derivative sign language, as is geography in relation to the countryside in which we have learnt beforehand what a forest, a prairie or a river is.[6]

A percipient subject is, in this way, fundamentally open to the world, and this open-

6. Merleau-Ponty, 1962, p. viii-ix.

ness is furthermore the primary access and intake to the world inasmuch as this openness must be sought and cognated through sensory experience.

This experience is an ante-subjective openness, an ante-subjectivity which simultaneously makes it possible for Merleau-Ponty to declare that the world is also ante-objective. A reflection on the world will, just as it sounds, be a mental act, an action which presupposes a "something" before the reflection. Between subject and the world there will exist a number of domains, an intermediate world, a material which stands in relation to subject and world. It will produce this figure:

This ante-subjective and ante-objective world can be represented by a circle, a domain, delimited and located between subject and world. A mental act and a sense perception can be imagined as an arrow which is sent off from a subject; the primary and original world will then constitute an undulating, tactile sphere within the circle; the reestablished and straight part of the arrow outside the circle could then be imagined as being a conscious reflectory act.

If we take up again the example with the landscape which contains both impressions, colours, sounds, and so forth, together with the abstraction in naming of these as being a geography, it would be possible to point out that the impressions will be contained in the circle; the reflection and the naming will be outside the circle.

A very exciting problem is to what extent this pre-subjective and pre-objective original presence-world can be thought of as being "ante," as it – viewed logically – cannot be described within the frames of an "anteness" without a reflectory and naming language, and thereby will lose the character of originality and unutterability.

To that Merleau-Ponty would reply that precisely language clarifies this problem:

The separated essences are those of language. It is the office of language to cause essences to exist in a state of separation which is in fact merely apparent, since through language they still rest upon the ante-predicative life of consciousness. In the silence of primary consciousness can be seen appearing not only what words mean, but also what things mean: the core of primary meaning around which the acts of naming and expression take shape.[7]

In this way Merleau-Pontian phenomenology becomes a manoeuver between what he designates as an idealistic transcendentalism and a nominalistic *Wortbedeutung* (word meaning). Phenomenology becomes a so-called eidetic reduction:

7. Merleau-Ponty, 1962, p. xv.

The eidetic reduction is, on the other hand, the determination to bring the world to light as it is before any falling back on ourselves has occurred, it is the ambition to make reflection emulate the unreflective life of consciousness.[8]

The concept "intentionality," which is discussed by Merleau-Ponty as phenomenology's most important discovery, is henceforth the decisive problem. It is Merleau-Ponty's aim to establish a so-called "total intentionality".

　　Merleau-Ponty takes his point of departure in Husserl, who thinks "being directed towards something" in two separate parts; one part is thought of as being active in our gratuitous judgements – "our judgements"[9] – and decisions; the second part is thought of as being:

that which produces the natural and antepredicative unity of the world and of our life, being apparent in our desires, our evaluations and in the landscape we see...[10]

-The above is a very significant passage for this work, for here we see an important connection between phenomenology and a possible theory of the imaginary; this phenomenology is, after all – as it will turn out – an intuitive theory of the imaginary.

　　In reading Husserl's two intentionality theses, they can immediately be connected to the stratifications of the imaginary, and the first part – the judgements and decisions part – can be thought to be contained in the stratum which is here called the socio-imaginary. Husserl says simply that there exists an intentionality, an attitude to the world which first and foremost concerns itself with the concrete and communally valid and experiential – the juridical socio-imaginary. This figure can be elucidated in the stylized G, which depicts the "folded imaginary" globally (cf. Chapter 5 below):

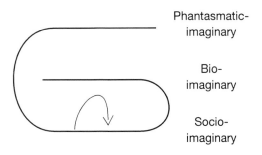

Phantasmatic-
imaginary

Bio-
imaginary

Socio-
imaginary

8.　Ibid., p. xvi.

9.　Ibid., p. xviii.

10. Ibid., p. xviii.

And from this it is easy to subscribe to the second of Husserl's intentionality figures being able to be thought of as being part of a phantasmatic-imaginary, inasmuch as the question here is of an accentuation of desires, evaluations and so forth.

This part can be invested in the stylized G thus:

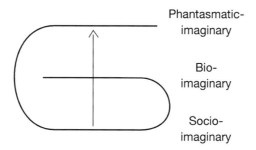

Phantasmatic-
imaginary

Bio-
imaginary

Socio-
imaginary

We therefore see a phenomenology founded on two of this paper's theses.

Merleau-Ponty thinks this intentionality figure a step further – so that there is now question of a complete agreement between the phenomenology and the imaginary. Merleau-Ponty pleads for a total intentionality, for, as he writes:

> Whether we are concerned with a thing perceived, a historical event or a doctrine, to 'understand' is to take in the total intention – not only what these things are for representation (the 'properties' of the thing perceived, the mass of 'historical facts,' the 'ideas' introduced by the doctrine) – but the unique mode of existing expressed in the properties of the pebble, the glass or the piece of wax, in all the events of a revolution, in all the thoughts of a philosopher.[11]

Note that Merleau-Ponty speaks of a "representation," equivalent to the phantasmatic-imaginary; about "the pebble, the glass or the piece of wax", equivalent to a bio-imaginary experience stratum; and finally about historic events and doctrines, equivalent to a socio-imaginary stratum.

This intentionality can be invested in the stylized G (cf. Chapter 5) thus:

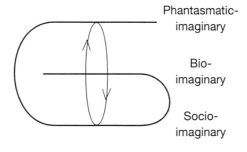

Phantasmatic-
imaginary

Bio-
imaginary

Socio-
imaginary

11. Merleau-Ponty, 1962, p. xviii.

In the above graph we see philosophical phenomenology in a clear connection with a socio-, a bio- and a phantasmatic-imaginary world. An exciting experiment might be to close-read a Merleau-Pontian phenomenology using such optics.

A next place where a new reading can be fruitful is naturally in the question of a possible connection between the morphology and what this phenomenology designates "beings" or "essentials":

There must be beings for us which are not yet kept in being by the centrifugal activity of consciousness: significations it does not spontaneously confer upon contents, and contents which participate obliquely in a meaning in the sense that they indicate a meaning which remains a distant meaning and which is not yet legible in them as the monogram or stamp of thetic consciousness.[12]

The above intuition surrounding indirect content elements, which both touch on and are not entirely present, can be paralleled partly with a conceptual schematics (cf. the following chapter), also partly with the thesis of the thymic morphologies and values. Conversely, the morphology can be imagined in a Merleau-Pontian language – precisely as beings, essential attitudes which underlie the narrative surface.

And in the same manner these preconscious essentials, or morphologies, become comparable to the total consciousness figure, which in another way is also discussed as a phenomenal body, in which consciousness, that is "my consciousness":

is not the synthetic, uncreated, centrifugal unity of a multitude of 'consciousnesses of...' which would be centrifugal like it is, that it is sustained, subtended, by the prereflective and preobjective unity of my body. This means that while each monocular vision, each touching with one sole hand has its own visible, its tactile, each is bound to every other vision, to every other touch; it is bound in such a way as to make up with them the experience of one sole body before one sole world, through a possibility for reversion, reconversion of its language into theirs, transfer, and reversal, according to which the little private world of each is not juxtaposed to the world of all the others, but surrounded by it, levied off from it, and all together are a Sentient in general before a Sensible in general.[13]

Here it is ascertained that this philosophy of "pre-ness" is capable of advancing its object to the advanced material, which, so to speak, "answers" back and reflects the subject-object in a surface – as a phenomenal bodiliness[14].

The question is whether it doesn't bring clarity to this, one might say, relatively compact and (fascinating) *écriture*, if it is basically assumed to be a theory – *also* – of

12. Merleau-Ponty, 1964, p. 165.

13. Merleau-Ponty, 1968, p. 141-142.

14. By body is not necessarily meant the body as object: "but on the contrary as a constituting part of the human life universe" (Olsen 1993, p. 37).

the imaginary's stratifications of a collectively socio-imaginary stratum and the strata of the individual bio- and phantasmatic imaginarities.

In any case, Merleau-Ponty imagines the "extension and reflection" he discusses as being a process which takes part both in a subject and an object, both the one thing and the other. A processual mode of thought which will be synthetic and dynamic, present here and there. Surprisingly, it is henceforth that Merleau-Ponty also sees a connection with the elements:

The flesh is not matter, is not mind, is not substance. To designate it, we should need the old term "element," in the sense it was used to speak of water, air, earth and fire, that is, in the sense of a *general thing*, midway between the spatio-temporal individual and the idea, a sort of incarnate principle that brings a style of being wherever there is a fragment of being. The flesh is in this sense an 'element' of Being.[15]

The question is whether Merleau-Ponty isn't inserting the flesh – *"la chair"* – and the elements as dynamic units, topologically anchored between the individual in a concrete world (facticity) and the idea (the notions). Notice the intuition which conceals itself in the term "style of being": to have a style implies having a rhythm. Elements and flesh are dynamic properties in and of being:

If we can show that the flesh is an ultimate notion (...) and if I was able to understand how this wave arises within me, how the visible which is yonder is simultaneously my landscape ...[16]

Notice that there is question of a "wave movement." Why isn't there, a question of an "airy" movement?

To that I will reply that this is due to the basic intuition which Merleau-Ponty follows: a euphoric nearness and, here, a tactile connection between thought, subject and object, combined in a phenomenal body experience, observes a wave movement because the latter is continuous, dense, tactile and euphoric. Here the wave functions as the thought's form.

And further we read, in a philosophically fascinating tour de force, that the elements are parts of perception but also, fundamentally seen, bodily; they are existing states:

Perception opens the world to me as the surgeon opens a body, catching sight, through the window he has contrived, of the organs in full functioning, taken *in their activity,* seen sideways. It is thus that the sensible initiates me to the world, as language to the other: by encroachment, *Überschreiten.* Perception is not first a perception of *things,* but a perception of elements (water, air...), of *rays of the world,* of things which are

15. Merleau-Ponty, 1968, p. 139.

16. Ibid., p. 140.

dimensions, which are *worlds,* I slip on these 'elements' and here I am in the world, I slip from the 'subjective' to Being.[17]

From here it isn't far, for a philosopher like Merleau-Ponty, to tackling a connection between precisely the imaginary and the elements. We read in a note:

Being and the imaginary are for Sartre 'objects,' 'entities' – For me they are 'elements' (...) that is, not objects, but fields, subdued being, non-thetic being, being before being – and moreover involving their auto-inscription their 'subjective correlate' is a part of them.[18]

Fields, non-thetic being and a fundamental intuition about the elements as sitings beneath what one might visualize as a discursive and communicable surface – this constitutes the Merleau-Pontian pre-subjective and pre-objective philosophy of "preness."

And Merleau-Ponty does think this pre-being – "being before being" – into a complex alliance figure: the essentials mentioned earlier. What is interesting in a "complexifying" like this would, in a catastrophe-theory context (- complexity in the catastrophe-theory context, cf. Chapter 4), is the way in which the concept of essence is assigned density ("its thickness"), – continuity – during the manifestation: speech, for example. We read:

The essence, the *Wesen.* Underlying kinship between the essence and perception: the essence, likewise, is an inner framework, it is not above the sensible world, it is beneath, or in its depth, its thickness. It is the secret bond – the Essences are *Etwases* at the level of speech, as the things are Essences at the level of Nature.[19]

Notice formulations like: inner framework, depth, materiality, and the reappearing "beneathness": that a "something" is underlying speech ("beneath"), just as things are essences in nature. A thesis might be that this "beneathness" is a continuistic figure in relation to discontinual speech.

And if we pursue the theory that the concept of essence can be made parallel to morphologies it is possible to show this significant formulation:

The absolute here of my body and the 'there' of the perceptible thing, the near and the distant thing, the experience I have of what is perceptible to me and that which the other person should have of what is perceptible to him – all are in the relationship of the 'fundamental and original' to the 'modified.' Not be-

17- Merleau-Ponty, 1968, p. 218.

18. Ibid., p. 267.

19. Ibid., p. 220.

cause the 'there' is a lesser or attenuated 'here,' and the other person an ego projected outside; but because (according to the marvel of carnal existence) along with the 'here,' the 'near,' and the 'self,' there is set forth over there the system of their variants.[20]

Here one remarks schema-morphologies like the "near" and the "distant," just as an external space is indicated with the deixis "over there."

At this point I will leave Merleau-Ponty and turn now to the present-day French philosopher and historian of knowledge Michel Serres. In the following we will review features of the work *Les Cinq Sens* (The Five Senses, 1985).

With Serres's *Les Cinq Sens* we are speaking of what one could call an aesthetic phenomenology; this aesthetic phenomenology naturally has features in common with the Merleau-Pontian phenomenology; what connects them is the common phenomenological explanation basis, but from there on the differences are also great.

A single – and perhaps the most important – difference is in the fact that while Merleau-Ponty works on finding a philosophic and reductive metalanguage, Serres works in constant scepticism towards any reduction (in any case in *Les Cinq Sens*):

Clear and distinct cognition results from analysis which divides or separates, irrepressibly disgusted by confusion (...) To analyze means to destroy (...) The theory of knowledge does not tolerate composition. But the confusion composes a liquid multiplication in which multiplicities play non-discretely, changing in continual varieties (...) It is as if the analysis hadn't yet accepted these complex and varied functions which it itself has treated for two centuries. We return again to the mixture and to the concept of variety, immediate in the rich, complex, lively experience of the senses...[21]

To return back to the mixture, the variety, the complexity and the composition is practiced in an aesthetic phenomenology which takes off from what Serres calls a *Philosophie des corps mêlés* (Philosophy of mixed bodies); a philosophy which unlike Merleau-Ponty's now employs the skin. And Serres puts forth the question of the mixed body, which results in a phenomenology which has as its aim to think a fluid, chaotic world and a sensing body in this flow. This takes place mainly in a single parameter, namely tactility.

Tactility becomes a model of cognition. And this so-called generalized tactility is thought of as double; it is both a sensing and a sensed skin. Tactility is the manner in which a generalized objectivity is possible. The touched and the touching skin:

is a variety of contingence: in it, by it, with it, it touches the world and my body, the sensing and the sensed are touching each other, it defines their common edge. Contingence means common tangency:

20. Merleau-Ponty, 1964, p. 175-176.

21. Serres, 1985, p. 181-182.

world and body intersect in it, in it they caress (...) The skin places itself between several things of the world and makes them mingle.[22]

And the world, if not an amorphous source of noise, is then a massiveness of impressions that imprint the touching and the touched skin. The skin is concretely human, but it is also a surface, a tissue, a textile; it is a simulacrum in which Serres discovers the philosophical point that the world, body and the connections between the subjective and the objective are to be understood as surfaces – topologies; the skin occupies no depth, generalized tactility is found on the surface:

In generalizing this hypothesis one can say that the tissue, the textile, the stuff provides excellent models of cognition, excellent quasi-abstract objects, initial varieties: the world is a heap of laundry.[23]

The wording runs: topology is tactile in virtue of physicality.

That this is an aesthetic phenomenology which has generalized tactility as the goal of objectivity, with the skin as an "inter-world," far from excludes it being a question of a philosophically cognating philosophy. Through the aesthetic and the beautiful, Serres finds the manner and the model by means of which cognition becomes possible. In so saying, the aesthetic is not relegated to a mere suposition in a humanistic metalanguage; everywhere in *Les Cinq Sens* Serres draws on this field – alongside an extensive and learned polyhistorical praxis in general. In more than one sense this is a philosophy of mixtures.

We shall examine the elegant analysis *Toile, Voile, Peau* (Canvas, Cloth, Skin)[24], which is a reading of the impressionist painter Pierre Bonnard's works; this will serve as a description of Serre's aesthetic phenomenology.

Here we have five readings of Pierre Bonnard's works from Serres' hand.

That Pierre Bonnard happens to be an exemplary elective affinity for Serres is connected with what for Serres is a characteristic of impressionistic aesthetics: Bonnard and what Serres calls radical impressionism are typically phenomenological in the accentuation of tactility. Bonnard's mottled and dappled impressionism, especially in the nudes, are radical examples of tactility. And his works can refer to a double stop between, on one hand, an aesthetic-impressionistic praxis of pressure and tactility, and on the other, a figural realism in which people and the world, through Bonnard, are

22. Serres, 1985, p. 82.

23. Serres, 1985, p. 85.

24. In citing from *Toile, Voile, Peau* I wish also to draw attention to the remarkable book *Billedets onde ånd* (The Picture's Evil Spirit) in which a Danish translation appears (as *Lærred, Klæde, Hud*). The book is published by the Royal Danish Academy of Fine Arts in Copenhagen. In recent years the Academy has distinguished itself as the central Danish forum for new philosophy and aesthetics, etc. - frequently in collaboration with the publishers Basilisk.

inscribed in a generalized impressionism. In a way we are all impressionists. Impressionism is based on phenomenology:

Through half a century Pierre Bonnard gave us his various exuviations, his flayed membranes. We think we are seeing pictures, but no, the mirrors are emptied, this is skins, delicate and receptive (...) Bonnard's kimono, his nudes, his gardens show us the skin's tactile flora.[25]

The skin becomes a map of sensation, a map of cognition and phenomenology – and so saying a topological map; we note the metaphorics in the above example: there is question of "the skin's tactile flora", the skin is human and topological in the sense that it refers to a topos; a garden with beds of plants, flora, earth and elements.

This topological map of sensation contains, as is seen, the touching and the touched skin. And simultaneously with this the elements become active; a theory of the elements is not developed in a special discourse, however. They are merely there, as they must simply be understood as being a part of the topology – and this topology consists, among other things, of elements. The elements are present as the backgrounds which belong to the surrounding world, the backgrounds which in themselves flow and have no substructure, but also precisely therefore *are* substructure and surfaces.

The elements are a part of what Serres would call multiplicity, and they can without further ado be referred to a place in a technical or rational language. The elements are a part of everyday language; philosophy has to make use of this everyday language because it is cognating and works directly in thought and in beauty, in contrast to a technical and rational discourse that would exclude this frayed topological language:

With that you can probably see why I utterly disinvest with regard to technical language, the technical usage of philosophy, which is always tied to an ignoring of the spectrum. It always presupposes the idea of the excluded third [tertium non datur]; but the study of multiplicities can't assume this void between the categories, it has rather to use the vocabulary of everyday language, which in return is frayed and encompasses a wealth of semantic areas with fluid boundaries.[26]

And this fluid elemental language and everyday language *is objectified* because it belongs to the mixed body; this body is at once a subject and an actual "frayed" topology.

One of the Bonnard pictures analysed shows a woman at her toilet in front of a mirror, *Nu au miroir* (1933):

25: Serres, 1985, p. 35.

26. Serres, 1983, p. 141.

She washes, makes up and paints herself. She masks her skin, with undercoating and priming, just like the painter grounds a canvas. The skin is identified with the canvas, just as the canvas before was identified with the skin (...) An impressive imprint on this envelope of parfumes, cremes or makeups. The subject's skin is objectified...[27]

Serres now reconnoitres the etymological connection between cosmetics and cosmos as being from the same root. Cosmetics denotes the embellishing, cosmos the arranged and ordered.

The woman at her toilet arranges her body exactly as a manifold world appears, the senses become a mimesis of the external; the senses arrange the disarranged:

Cosmos denotes the arranged, the harmonic and the regular, appropriate: here is the world, here is heaven and earth, but also the made-up, beautified, put in order. Nothing is so deeply significant as the makeup, nothing so far-reaching as the skin, the ornament assumes the same extent as the world. The cosmic and the cosmetic, the appearing and the being emanate from the same source. The makeup is equivalent to the ordered, and beautification to the law, the world appears ordered at whatever level you grasp the phenomena.[28]

And while this cosmetics of sensation is equivalent to multifariousness it can be added that Serres thinks his philosophy in some simple schematic paradigms: that would be the "arranged" as opposed to the "disarranged," in which senses, multiplicity and elements leap forth on the same dynamic background.

This is implied in everyday language, the everyday language which acts on the elements' morphologies. Meanwhile, order and the disarranged can be developed further to also encompass a paradigm like: the "solid" as opposed to the "fluid."

Serres' philosophy makes use of everyday language, and this is once more frayed, but in particular it is fluid. Beauty and cognition through beauty must be fluid – viewed morphologically – if it is to grasp the multifarious, in contrast to an ideal of, in a technical and systematic philosophical language, analysing a "spectrum" and excluding instable forms – and thereby become a solid language. Note the following quotes from the Bonnard analyses. Here we see how Serres works on the elements' fluid morphological background:

Strewn with moons or half-moons, sprinkled with sickle moons which are darker, the tissue *vibrates* from light and shadowed regions[29]

27. Serres, 1985. p. 30-31.

28. Serres, 1985. p. 30.

29. Serres, 1985, p. 27 - the emphasis is mine.

What *wind* will lift this apron[30]

The body nude, tatooed, chaotic and *effervescent* with colours wears outside its own sensorium's both general and momentary form a landscape of plains and elevations, where currents *emanating from or flowing towards the senses* are mixed[31]

currents of hearing, rivers of taste, lakes of listening, mingled and babbling watercourses from which her beauty arises[32]

this piece of heaven, this bowed, *moist* corolla[33]

Not models to paint from, but models of what must be done if one day there is to be painting or thinking: you hurl yourself nude out in the *ocean of the world*. You feel this membrane, this tissue, this *veil* is formed around you.[34]

Precisely this membrane becomes important as the take-off for the further thinking Serres carries out by this aesthetic phenomenology – inasmuch as the mingling and the skin are tied on to epicurean simulacrum thinking:

The old epicureans called these fragile membranes which float in the air, are transmitted everywhere and are received by us, and whose function it is to make signs and give meaning, simulacra. (…) They simulate, to be sure. But in particular they do something else: emanating from the painter's skin and things' delicate envelopes the one's veils encounter the others' veils, the canvas grasps the spent sloughs' momentary union. A simultaneous simulacrum.[35]

These simulacra operate on the multiplicity's and the elements' "fluid" ground: and realism which is converted and is encountered in the senses' morphologies.

I will now very briefly assemble and summarize this review of the two phenomenologies. For this I will set up the following schematic opposition of the two philosophies:

30. Ibid., p. 28.

31. Ibid., p. 31-32.

32. Ibid., p. 32.

33. Ibid., p. 32.

34. Ibid., p. 34.

35. Ibid., p. 36.

Merleau-Ponty:	**Serres:**
Essence	Mixture
Elements = non-thetic Being	Elements = everyday language
Depth	Surface
Hierarchy	Being = manifestation
Flesh	Skin

With Merleau-Ponty a depth surface is found, an always original language which makes the basis *beneath* any experience and perception of the surrounding world; with Serres it can be said that there is probably question of a similar language, but where in Merleau-Ponty it is referred to a being-depth in the flesh it is now a pure and simple non-hierarchical surface, and:

The cognition does not consist in undressing or unveiling things, but in letting the veil or clothing of things – the subtle simulacra – cling close about the skin's (that is, the senses') pellicles, in letting the world's forms press themselves – kissing, embracing – against the cognating subject.[36]

And as is shown along the way, elements and morphological backgrounds carry out significant structures:

In Merleau-Ponty as a being, a virtuality concealed beneath an everyday world. My question in this connection is whether Merleau-Ponty, parallel with philosophical phenomenology, doesn't *also* intuitively develop a theory of the imaginary in human thought.

In Serres, elements are seen as a part of everyday language, the everyday language which lies not as a depth but as a surface – a surface in which manifestation and being are the same.

At this point I will leave this phenomenology and turn my attention to a newer type of phenomenology: a cognitive phenomenology.

36. Lyngsø, 1994, p. 325.

3. COGNITION AND MORPHOLOGY

Two opposite points of departure appear to apply in what is understood as recent "cognitive science."

One paradigm will establish a cognitive semantics on the basis of a concretely experienced physical body, and the other appears to tend in the opposite way, inasmuch as we are here speaking of establishing cognitive structure as a result of morphological characteristics (in the sense of word class) and structural differences: *structures of meaning.* There is question of a bodily cognition as opposed to a structural cognition.

In this chapter I will present these considerations taking as a basis Mark Johnson's work "Philosophical implications of cognitive semantics," and then with a basis in *Cognition and The Semantics of Metaphor* by Per Aage Brandt (1995). Finally, I will relate to linguist Leonard Talmy and advance the question of "force dynamics" in sentence structures.

Mark Johnson's bodily-cognitive endeavours consist in locating subject and meaning in a parameter like "body" and "surroundings." This gives occasion for the following:

We are beings of the flesh. What we can experience, how it can be meaningful to us, how we can reason about it, and how we communicate this understanding to other people depends on the patterns of our bodily experience (...) The form and content of meaning at this bodily level are, for the most part, non-propositional and beneath the level of conscious awareness. That there should be such a deep level of significance makes good sense from an evolutionary point of view.[37]

Johnson's thesis is that the prelinguistic depth level consists of simple picture schemas, which constitute source areas for the metaphors. Regarding picture schemas Johnson mentions in particular physical experiences from macrophysics. They are phenomena like force, weight and constraint, centre and periphery, articulation and content:

Consider, for example, our bodily experience of force. Thousands of times each day we either experience natural forces acting upon our bodies or we exert physical force on objects in our environment. We feel the wind in our face, the baseball smacking our glove, our acceleration as we step on the gas pedal.[38]

And of interest for this paper is that Johnson sees a fundamental verticality schema which generates universal experience:

37. Johnson, 1992, p. 347-348

38. Ibid., p. 347.

It is hard to imagine a human being without an up-down orientation within our gravitational field, or without some experience of bodily symmetry."[39]

Using such schemata, Johnson arrives at the conclusion *that the spirit is like the body* and more important: to understand is to see. This means that the sensing of a surroundings becomes a general metaphoric system. In brief: *to understand is to sense.*

And the distance sense – vision – becomes an especially privileged source area, which structures the metaphoric surface. Johnson establishes the following paradigm[40]:

Visual domain		Knowledge domain
Object seen	→	Idea/Concept
Seeing object	→	Understanding idea
Ambient light	→	"Light" of reason
Visual focusing	→	Cognitive attention
Visual acuity	→	Intellectual keenness
Point of view	→	Intellectual perspective

The point is that the vision is a significant source area which is transferred to the immaterial knowledge and vice versa. The metaphorising can be carried back to the source area.

The visual domain and the knowledge domain take part in what can be called a hermeneutic interpretational praxis: a source leads ahead to a knowledge; in this way the spirit's concept formation is regarded as being material; it is established on concrete objectal sources.

Statements like: "I saw the solution immediately" or "Can you grasp the essential idea," have as source the distance sense and the near sense (see and catch, eye and hand), and the abstract knowledge domains (solving and the essential) become concrete. To grasp an idea presupposes a hand which seeks out an object, and this object is 1) concrete, and 2) metaphorized as being an idea; it is established on concrete objectal sources.

Johnson now generalizes this concretion of the spirit to an interpretation praxis in which the sentence and the communication between people become – as mentioned – a hermeneutics: a transport from an image schematic depth level to a metaphoric level. In statements like: "She got her idea through" or "Don't give me any more of that nonsense", one thus understands a transport by that path *of idea-objects* to a receiver.

If one "attacks" such a bodily cognition (here in such a statement Johnson would, for example, presuppose that a concrete battle scene is at the basis of the verb to attack),

39. Ibid., p. 354.

40. Ibid., p. 354.

one can pose the question which the psychologist of language John M. Kennedy refers to, namely that the linguistic structure itself and the communication are so extensive:

that in any area of experience we will always be able to find competing implicit metaphors, and assert that precisely they structure our experience and linguistic usage at a 'deep' level.[41]

Kennedy's problem, which is a basic problem in "Cognitive Science" generally, is the virtual usage in the surface in relation to the depth level.

As Kennedy mentions, different paradigms will constantly be in conflict:

We can say that "we want to bone out the consistency of this viewpoint" or that "his speech had neither head nor tail," by which we apparently are guided by the argument being a body. But we can also "sell out" on our viewpoints in a debate, "make a speech that is pure bluff," or "overbid the opponent's lead with a more general argument," which suggests that the argument is a game.[42]

If the above is one problem we can add a new problem with this hermeneutic bodily cognition, namely the question as to the generalization level itself in the theory.

For example, it must give problems that the background light in the vision's source area can carry with it a knowledge area which is rational. The light and the object concept, the reason, imply hereby a basically continual philosophical ontology. And what would Johnson, for example, do with the discontinual light, or with the awe-inspiring light, the light which creates anxiety? Here we are not speaking of an epistomological light but, on the contrary, a phantasmatically invested light.

The structural cognition will, in relation to Johnson's bodily cognition, probably assert that there exists a depth which is pre-intentional and comes before the statement surface, but this depth is a *structural background*, which can't be comprehended in an unequivocal quantity such as the human body alone. Conceptual pre-intentional structure comprises a fluctuating and amalgamate multiplicity. Conceptual stucture cannot be comprehended, it cannot be felt:

it refers to structures of *meaning*, not to structures of real-world entities (physical, or social).[43]

Exactly this structural aspect refers accordingly this theory to a study of the metaphor (an aspect with which I won't go into detail), but also to the morphological-linguistic dimension, that is, the word classes' possible semantics and linkage to conceptual and pre-intentional structure.

But sketched briefly, the metaphor will in this connection constitute a complex

41. Stjernfelt, 1993, p. 45.

42. Ibid., p. 45.

43. Brandt, 1995, p. 141.

signification; it will be a redoubled representation on an iconic level; it will contain an implicit information; it will be an occasionally usable circumstance which now and then turns up; it will be a generic meaning formation, and finally: it is concluded that the metaphor will be related to the different "fields of experience."

And, ultimately, it is added that the metaphor's meaning is stretched between a conceptual and a semantic structure on the basis of a lexical and morphological material.

But what is conceptual and semantic structure according to the structural cognition?

For both areas – and for the theory as such – valid as a philosophical framework is that the theory is a further development from a "soft" phenomenological tradition where the intentionality problem, for example, comes into focus, for:

it appears to this author that phenomenology as a *methodology* and semiotics as a corresponding *ontology* prepare a cognitively oriented framework...[44]

And further:

Any intentional expression must, according to scientific (systematic) semiotics, rely on previously structured representations and structural principles of organization linking these representations and combining them in larger 'discursive' units, such as narrative patterns, argumentations, and descriptions (...) The idea is that intentional meaning is built out of pre-intentional elements, is based on non-intentional meaning.[45]

In any case, the semantic content or image quantity can be divided into so-called registers, which are called worlds and abbreviated: W.

The idea is that the semantic structure consists of three semantics; a first world which is based on "pure" simple perception, called W1, and delimited by a physical body – here we have a possible parallel to the Johnsonian bodily cognition, although W1 differs from the Johnsonian body in the fact that W1 is only a single one of three parts in the collective semantic world.

Accordingly we find a second world: W2; it consists in a social, collective sphere primarily based on communicative actions among people.

And finally, a third world is found: W3; it can be thought of as a mental psychic and fantasmatic semantics. Contained herein are individual emotions and ideas.

These worlds constitute semantic units which – as will be seen – can be linked up distributively to the morphological word classes.

44. Ibid., p. 141.

45. Ibid., p. 145.

The idea now is that *conceptual structures* project schemas that are non-logical or linguistic, so-called backgrounds, into the *semantic registers*.

For the sake of the overall view this can be illustrated thus:

$$
\text{Conceptual structure}
\begin{cases}
\textbf{W1}: \text{Perception (physical semantics)} \\[2mm]
\textbf{W2}: \text{Communication (socio-semantics)} \\[2mm]
\textbf{W3}: \text{Imagination (psychic semantics)}
\end{cases}
$$

This conceptual structure is accordingly thought to be a limited and probably delimited formal ground, a functional and "mechanical" background area:

Conceptual structure is finite – if not necessarily coherent. It is not a logical system; neither can it be a unified calculus or a geometrical axiomatism. It seems more probable, if also more inconvenient, that it can be described as an ordered list, a stratified *bricolage*. There is a bottom level and a top level. Seen from inside, the transition towards abstract verbal thinking introduces – at the top level – an important instance of *generic* determination of entities or properties (a natural version of *all*-quantification); the transition towards hyper-concrete awareness – at the bottom level – introduces an inverse instance of *deictic* determination, yielding simple intentional attention to the *singularity* of unique 'somethings'.[46]

This bricolage is subsequently asserted to consist of a bottom area, a middle area and a top area. Each of them has a list of characteristics:

The bottom area is localised as consisting of *states,* which are fundamentally only a kind of attention structures. In this bottom area states appear which have to do with phenomena such as: figure and ground, verticality (and horizontality) and substances. Here one views the element morphologies: the solid and fluid, the "airy" and "watery," the dense and the diffuse. This area describes represented content, and a thesis would be that it is in this bottom area that the elements are localized as substantial states in the perception. Moreover, it would be here that a link-up can be made to a Merleau-Pontian "being before being."

In *the middle area* are found *events* which link up to changes. They can be kin-aesthetic changes, and it can be "force dynamics" (cf. below). Here we regard, among other things, a Johsonian imperative-force image schema.

Finally, we find in *the top area* a category which is called *fields*. Here relations a-rise such as number, analogy and comparativeness and containers of a choresmatic kind (to be in or out of something) are found (cf. Brandt 1983, see note 70). These categories will be spatial-temporal icons:

46. Brandt, 1995, p. 151.

that globally integrate states and events into patterns of intelligibility, by which "mental processing" obtains configurative meaning in any interpretation (...) Conceptual structure would then be a stratified collection of natural schemes, from which language selects semantically reinforced partial patterns.[47]

The argumentation can be summarized thus:

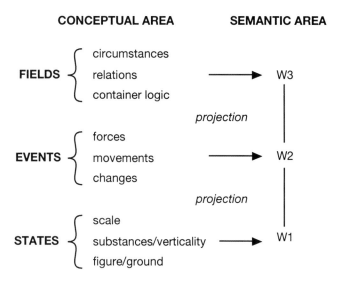

CONCEPTUAL AREA	SEMANTIC AREA

This conceptual schema inventory can't be communicated directly:

we do neither have three languages, one for each world, nor one unified language referring only basically to one of them...[48]

And when we cannot know the conceptual basis directly how can we speak of it at all? Here we have come to the semantic half of the argumentation again. I have already indicated a connection in the above schema and it shall now be exemplified.

It must be remarked, incidentally, that an epistomological axis can be ascertained in this work as such: something can be recognized in virtue of the fact that the recognition itself presupposes something else. In this way the theoretical work becomes an archeology but not a tautological one, *in so far* as the different areas' specific and objective multiplicities are acknowledged.

The semantic reasoning will be analysed in relation to two problems: in part to

47. Ibid., p. 152.

48. Ibid., p. 153.

produce the semantics' morphological bases, in part to be able to verify the conceptual basis in the linguistic structure's surface. These problems are connected.

For it is possible in the semantic surface – as seen above – to connect the perceptual W1, the communicative W2 and the imaginative W3 with a number of morphological bases, and:

My point is that different interactions and reinforcements in fact make any natural language an *amalgam* of lexical and morphological fixations having established basic meanings in different semantics. In that case, a language should be analysed by reference to sublanguages, according to these semantic distributions.[49]

The first area links up to the connection between the conceptual bottom and the semantic surface, which belongs to the physical perceptive W1 world.

This conceptual bottom is defined as a background which consists of states. This background of states has its morphological equivalent in the language's nominal and substantivistic paradigms. Pure perception is nominally oriented. The idea is, for example, that paradigms like air, water, fire and earth are a descriptive expression for simple states in the conceptual basis.

At a somewhat higher level the conceptual area accordingly figures consists of events. This area has its (natural) equivalent in the language's dynamic and verbal paradigms. Communication's W2 world refers to this conceptual area. Verbs such as go, come, give, speak, eat, write, and so forth, are communicative events in the subject.

Finally, we find the conceptual area that consists of so-called fields. This area has its morphological equivalent in the language's adjectival and adverbial world of description. The imagination's W3 world refers to this area; basic adjectival constructions like angry, glad, sweet, sulky, etc., are psycho-imaginative fields in the narrative surface. And all in all:

Syntax as a whole is phenomenologically *emotional* – sentences in fact carry affect, for instance by word order and intonation patterns, – because of the psycho-semantic reference, which is basic in field structure fixations.[50]

And the question – as the article's author also mentions – is whether this last thesis isn't carried to overly great lengths. The argument runs that adjectives, for example, can also refer to the perception of colour, sound, touch or to communication; but in the execution of such interpretations there is, on the other hand, question of emotional connotations. And in that way one can, on the whole, get connotative derivations in all the (open) lexical word classes. What is important is to note henceforth that

49. Brandt, 1995, p. 154.

50. Ibid., p. 155.

these connotative derivations are not basal – inasmuch as they belong to "the realm of compact meaning."[51]

Precisely the question of compact meaning, in the composition or in the narrative surface, is the problem inasmuch as every text or pictorial composition implies and contains a context.

Here the article points to the role that W2 communication plays. A text or a pictorial composition contains a message and an implicit communicative aspect: what does this deal with will be a spontaneous utterance at any acquisition of an aesthetic object; any composition or text will always contain a common world, an "olympic", non-situated viewpoint."[52]

The W2 world is the semantic area which makes possible that one feels the derivations inside the other areas (W1 or W3). It is important to emphasize that the W2 world makes it possible to speak of W1 and W3.

One recognizes this strongly in, for example, the literary or semiotic analysis; an aesthetic object can be analyzed, and the investigator finds, for example, phantasmatic 'features' in the object. This can only be done, however, to the extent in which we are speaking of a scientific common language to communicate this in. In other words, it is hardly possible to speak together exclusively and for very long at a time in pure imaginative or phantasmatic terms.

From a morphological point of view the derivations in the word classes and between the registers are tremendously important; the thymic morphologies and the schematic morphologies are active in the semantic area – but the question is to what extent can they be localized in the conceptual structure? In other words, do the morphologies come from the global and conceptual area up to the semantic or do they already exist in conceptual structure? One thesis is that, at any rate, the thymic morphologies appear at an intermediate step between conceptual background and semantic foreground, whereas the semantic oriented morphologies already exist in the conceptual background (cf. the conceptual states in the bottom area).

In any case, the grammatic morphologies are based on the thymic morphologies as well as the schematic morphologies.

Finally, with the above conceptual background it is in principle possible to regard a schematic basis under the semantic compact meaning; *and in this the elements can now be said to be conceptual states.* It can give a substantial renewed access to the question about the existential landscape in which a romantic feeling for nature, for example, takes part.

It is on the whole possible on the basis of this cognitive theory to show different genre possibilities:

51. Ibid., p. 156.

52. Ibid., p. 157.

Narrative realistic prose will come close to a W2 semantics: "allowing for extra-narrative, descriptive (W1) and emotive (W3) deviations."[53]

Painting and poetry will naturally be in a W1 semantics and "the field mapping W3 → W1 is a predominant common property of poetry and music."[54]

Drama will in virtue of its scenic character be a W3 semantics, though naturally it represents events (W2), however:

the stage matches directly the conceptual field structure, the field categories are essential in drama, and a rhetoric of containment (in/out oppositions), condition (powers, magical influences), relation (analogies, recurrent themes) is prevalent; music is therefore a natural counterpart, and opera is a genuine dramatic extension.[55]

The above cognitive theory analyses conceptual and semantic structure, and it puts forth a thesis which imagines "the manner in which one thinks" in different stratifications. And in this, as mentioned, the derivations between the areas are important because they must be thought of as being dynamic. And exactly the dynamic aspect leads on to this chapter's summarizing thoughts surrounding "force dynamics" in the compact sentence – such as theorized by the American linguist Leonard Talmy.

The idea is that a compact sentence structures meaning; but en route in this meaning structuring oppositional entities will struggle for mastery in the sentence. Talmy shows four examples of so-called "basic steady-state force-dynamic patterns"[56]:

A) "The ball kept rolling because of the wind blowing on it."

B) "The shed kept standing despite the gale wind blowing against it."

C) "The ball kept rolling despite the stiff grass."

D) "The log kept lying on the incline because of the ridge there."

In each of these sentences Talmy finds two oppositional forces; one is named the "Agonist," the other the "Antagonist" – and between them there will exist a causal and concretely anchored realistic tendency either towards action or towards stasis, that is, either movement or rest.

In the above examples are shown: a) a situation with a ball, the Agonist, whose innate tendency goes in the direction of rest but which is forced into movement by the

53. Ibid., p. 161.
54. Ibid., p. 161.
55. Ibid., p. 162.
56. Talmy, 1988, p. 53-55.

wind (the causality of natural forces). In this example we see a situation in which the Antagonist (the causality) is stronger than the ball.

In example b), the shed, the Agonist, remains standing in spite of the strong wind which blows against it; conversely here it is the wind, the Antagonist, which is weaker than the Agonist (the shed – whose tendency is stasis).

In example c), the ball, the Agonist, keeps rolling. The ball's tendency this time is movement, in spite of the Antagonistic grass: the Agonist is stronger than the Antagonist.

In example d), the log, the Agonist, whose tendency goes in the direction of movement on account of the slope of the hill, remains lying on account of the ridge, the Antagonist.

What one is dealing with can be characterized as a catastrophe theory in the intuitive sense, because it has to do with transitions between states which are thought of topologically anchored in macrophysics. What is interesting beyond this, however, is the role which the sentence's morphologically closed classes constitute[57] in the examples above – "despite" and "because of":

With the Agonist appearing as subject, the role of a stronger Antagonist can be expressed by the conjunction *because* or the prepositional expression *because of* (which in other languages often appears as a simple adposition), while the role of a weaker Antagonist can be expressed by the conjunction or the preposition *despite*. Force-dynamic opposition in general can be expressed by the preposition *against*...[58]

This must be taken altogether literally. There is actually question of a linguistic concretion in two ways: partly in the examination of the morphological material (prepositions and conjunctions, the closed word classes on the whole); partly in the reference to causal, external macrophysical phenomena that determine the meaning's content.

These observations will be used in the analyses, though it must be remarked that there is a problem in finding examples of employing this type of conjunction and preposition as in the examples and in the above quote, for the simple reason that they appear more frequently in everyday language than in poetic language.

But the above is, as mentioned, an intuitive catastrophe theory, and in the following chapter the catastrophe theory will be developed on that background.

57. See note 100 below, where I describe briefly what a closed word class is.

58. Talmy, 1988, p. 56.

4. DYNAMICS AND MORPHOLOGY

In the preceding chapters we have been speaking of a soft and a hard phenomenology, respectively: a pre-schematic philosophic and a newer schematic cognitive phenomenology.

In this chapter I will review aspects of the catastrophe theory, partly in order to clarify the methodological-technical foundation for this semiotics, partly in order to provide a necessary foundation and foreword for this paper's central argumentation: *the question of imaginary meaning formation and the morphology in the aesthetic context.*

I will implicate in this review the thesis that the present catastrophe theory paradigm combines a soft and a hard phenomenology, insofar as we are speaking of a strict formalizing into a hard terminology together with a soft investment of phenomenological theses. These two levels are mutually dependent on each other.

Use of the catastrophe theory paradigm en route in the paper has already been suggested. The idea now is that the catastrophe theory paradigm constitutes a third major inspiration in the history of semiological and semiotic theory.

That we are speaking of a third major theory development can be perceived in relation to the linguistic-semiotic basis through F. de Saussure and subsequently through the semiotic systematics developed by A. J. Greimas.

The catastrophe theorem will in relation to these semiological and semiotic bases be a three-dimensional theory, which in relation to the Saussurean basis can be thought of as a one-dimensional theory development, and Greimas's as a two-dimensional theory development.

The point of departure for this thesis is the theories' appearance in relation to the topology in the space. What is meant by this?

The one-dimensional Saussurean basis comes into being in the constituting of relational paradigms; thus in this semiological tradition one distinguishes between, for example, the linguistic structure (langue) in contrast to the linguistic usage (parole); these two planes are connected to each other relationally. They can't be thought of separate from the linguistic practice. From this, then, follows a concept of the sign as the preeminent epistomological basis. This sign is redoubled again in the famous relationship: signifiant and signifié:

In the Saussurean tradition the term *signifié* characterizes the one of language's two planes (the other is *signifiant*), whose combining (or semiosis) during the linguistic act forms signs which are significant. The *signifiant* and the *signifié* are defined by a mutual presupposition relation; this definition, which is of an ope-

rative character, satisfies the semiotics which desists from any ontological judgment of the signifié's nature.[59]

This relational basis may consist of contradictory units, but meanwhile the relation between them serves the combination of a sign; this is emphasized, for example, through the psychological imprint which the sign is given by Saussure:

The linguistic sign is then a two-sided psychological entity (...) I call the combination of a concept and a sound-image a *sign...*[60]

This can be depicted as follows:

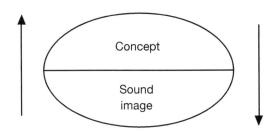

Here we see the combination depicted in the form of a circle, and the sign's psychological relations are given in the arrows outside the circle. The relational intuition is thought of as vertical upward and downward movements, but fundamentally in a delimited psychological and chorematic space. One could be tempted to think that what we are speaking of is a zero dimensionality; viewed mathematically, the circle and the point are without dimension, but this two-sided psychological entity appears in a complex linguistic act, however, which then in principle appears as an epistomological tool on several planes; the idea is to form a study of "the life of signs within society"[61].

And this systematics is in its point of departure a one-dimensional line; the sign's fusion is in a linguistic act and works accordingly in an establishment, production and recognition of relations and as relational networks as reflections on the life of signs.

This psychological and fused sign which cannot be separated, just as the two sides of a piece of paper cannot be separated, appears accordingly as resulting from an establishment of the social life of signs in a thesis of the arbitrary and differential status of signs. This arbitrary point of departure in what must be arbitrary, relational

59. Greimas, 1988, p. 231

60. Saussure, 1959, pp. 66-67 - the graphic which follows is found on p. 66.

61. Saussure, 1959, p. 16.

networks, accordingly gives Saussurean linguistics a status as a fundamentally nomina-listic theory development. The sign and the development of signs is based on an essen-tial disjunction between "the world of reality and the world of language"[62]. In other words, it isn't a question of a theory on a topological basis proper.

This nominalistic starting point forms the foundation for the study of signs as structures, for example in the study of expressions:

The signifier, being auditory, is unfolded solely in time from which it gets the following characteristics: (a) it represents a span, and (b) the span is measurable in a single dimension; it is a line.[63]

And the intuition of a structure and a relational network like a chain and a sequence follows in this argumentation, where one also observes the one-dimensional develop-ment in the formalization:

In an accurate delimitation, the division along the chain of sound-images *(a, b, c)* will correspond to the division along the chain of concepts *(a', b', c')* .[64]

Belonging to which is the following graphic element:

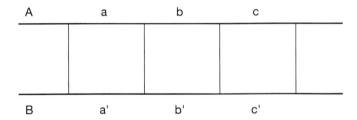

In the above we see the one-dimensionality formalized through a line, and this is thought of as a correspondence between parts that are fused in the sign's division between two sides.

The consequence of such a linguistic formalization and epistemology is naturally manifold. Saussure's theory development, as is well-known, has given rise to so-called structural analysis and semiology, and the theory is naturally a constant challenge also for dynamic semiotics. I won't go into this, only conclude that a one-dimensional theory like this very simply discards a properly external topology (and realism), and places the theory in the study of signs as psychological and immaterial.

62. Jefferson, 1989, p. 47.

63. Saussure, 1959, p. 70.

64. Saussure, 1959, p. 104 - The graphic element following this is also found on p. 104.

A next inspiration for dynamic semiotics is subsequently the inspiration which comes from the semiotician A.J. Greimas. And with Greimas the perspective of the line is annulled in favour of a flat square, in which a two-dimensional perspective is made out. A.J. Greimas bases his theory on the study of the semantic structures of narrativity, and:

> splits up in the tradition of Lévi-Strauss the semantics of language into two main levels, 1) an organizing semantics which processes and structures, 2) a given natural quantity of forms for significant content. On the one, external, side an *exteroceptive* stratum which correlates with the 'natural world's' given inventory of forms and objects (...) On the other, inner, side an *interoceptive* stratum, an inventory of 'consciousness semantics' whereby language grasps the world's forms and assigns them meaning, so that the first subsequently appear as significant: this level is termed *depth semantics* or simply *semantics*.[65]

We note that predicates are used as forms, objects, the natural world on the external and, now, topological side, in relation to which a consciousness participates with a language that grasps and assigns to forms in the world a meaning.

This division between a depth and a surface can be thought of in the famous tool, the figure which is called *the semiotic square.*

This semiotic square introduces a plane, a two-dimensionality. The square represents a loop between two stations, and the corners of the square are thought of as loci, topoi, which distribute units, sems, discontinually round about in the plane's centre. In a stripped-down form it looks, for example,[66] like this:

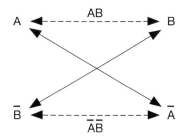

A/Ā and B/B̄ are contradictions, while A/B and B̄/Ā are contrary relations. Greimas imagines that these terms engender two complex new hierarchies, AB and the negated A̅B̅. The sems are articulated in squares of this kind, and what is important is that they are founded in relation to a depth semantics which in the above model can be thought of as being a depth that represents language's anthropological function. Greimas imagi-

65. Stjernfelt, 1992, p. 224.

66. See for example Greimas, 1988, p. 227-229, with an examination of the square's different generations.

nes that an objective depth of that kind in this anthropomorphic modelizing is catego-
ries such as life-death and nature-culture.

 The important thing in this connection is that the square reposes on a funda-
mental redoubling logic: a series of sems is distributed in the square's "local" interior in
relation to a "global" exterior.

 An articulation of this work will accordingly look like this, for example:

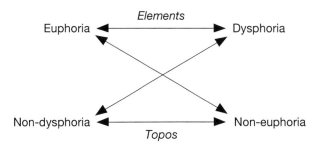

The thymes euphoria and dysphoria are contrary values which are negated as respec-
tively non-euphoria and non-dysphoria. These local movements articulate – purely
and simply around themselves – two metacategories, respectively the complex "ele-
ments," and on the other side, the neutral topos, the space itself.

 In this way the square becomes a visual representation of, in principle, any binary
semantic category's possible articulation, just as it buttresses the Saussurean dictum: in
language only differences are given.

 The square reposes on a two-dimensionality, partly in virtue of the topological
and anthropological dimension, partly in the internal visualizing of different hierarchi-
es. Meanwhile, it is characteristic of model formalization that the dynamic movement
within the square remains a non-articulated movement, this is seen as discontinual
jumps between loci, and these jumps don't allow for digressions, pauses en route or
other variations in the dynamic movement itself between the corners. In principle it
isn't possible to observe what occurs in the chain of events between the loci (corners)
of the square.

 This dynamic movement between loci now continues, in the theoretic history
semiotics draws upon, with the catastrophe theory. And here, in this paradigm, it
becomes possible in a greater degree, or in a three-dimensional sense, to stretch the
dynamic movement out – so that it becomes a matter of an expanded syntax in itself.

 I will now turn to the catastrophe theory and the dynamic three-dimensional
space.

 The catastrophe theory was developed by the French mathematician René Thom
during the course of the 1960s.[67]

With the term catastrophe theory it might be thought that what we are speaking of is an eschatological and normative theory of the collapse of systems. Meanwhile, the term *catastrophe* is merely a designation for the mathematical and topological model of a given system transformed from one state to another new state. The transition itself from state x to state y is a "catastrophe." The theory is concerned with phase transitions in systems.

René Thom develops this catastrophe theory on the basis of an analysis of biological systems. The embryo's development is thus a catastrophic process; first we have the fertilized egg cell, then the process of mitosis begins in which the egg cell divides in two, which again divide in two, until the cells' nuclear information and division has been transformed into a result: an infant. These transformations of state constitute prototypes for catastrophes, and every system which moves can in principle be thought of as having a catastrophic logos. Then the question is: how can these discontinual transformations, foldings and abrupt changes be possible?; how does discontinuity emerge out of continuity?

In any case, René Thom develops on the background of this scientifically based mathematics the so-called seven elementary catastrophes. I shall only be working with catastrophe number 2: the so-called *"cusp"*, or *"point catastrophe"* (from the French 'la cuspide,' meaning 'having a point' such as a spearhead).

If we construct this cusp in three-dimensional space it will have the following graphic form (like folding a sheet of paper):

This figure resembles a plissé, a fold, here in a sheet of paper. Projected in a temporal fourth dimension it can represent: *separation, generation, transformation and union.*

The cusp is based mathematically on the function: $f(x) = x^4 + ax^2 + bx$. The internal dynamics will be the representation that arises in a calculation of the values of the function $x^4 + ax^2 + bx$ for varying values of a,b.

This function can accordingly assume the following types on being placed in a system of coordinates:

67. The following exposition of the catastrophe theory refers to Stjernfelt 1992, Hansen 1989, but also *in particular* to the seminars I followed at the Center for Semiotic Research in Aarhus during the period from 1988 on, such as the seminar "Elements and Ideas" in April 1993.

What it is necessary to visualize is that a given system moves through spaces of states. If we read this system, this syntax from 1 to 7 we will get a run-through of the transformation between different local states. In states 1 and 7, a given situation is regarded in equilibrium, a ball, which represents a system that is attracted by minimas and in them is stabilized, can be imagined as resting at the bottom of what is called the well. In state 4 we have a situation in which the ball is surrounded by two wells; the situation is ambivalent: to which side will the ball fall? States 2 and 6 will imply, for certain, a fall down into the well (see moreover my mathematical enclosure, in which the quartic equation is performed).

The intention is that this series of states, for example, can be read from 1 to 7, in principle from a state of equilibrium across a series of discontinual menacing states ahead to a new state of equilibrium.

If this internal space is projected in an external control-topology we accordingly obtain a form, indeed, a cuneiform:

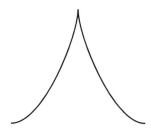

a modelizing of an external topology, which subsequently is open for interpretation.

If this interpretation is to be catastrophic, meanwhile, it must constantly be thought and controlled by the internal space's state variable.

The following cusp can be generated, where I superpose the internal series of states on the external cusp:

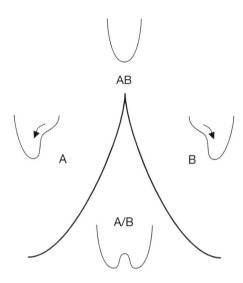

What one sees is the internal x,y space projected in the external a,b control space. In the control cusp's inner zone, between the legs of the wedge, there will be a state of ambivalent calm; if the balance is shifted beyond the legs of the wedge out in catastrophe plane A or B the system will have undergone a dynamic change of state. It is important to understand A or B as attractors which constantly threaten the ambivalent calm between the legs of the wedge. The state AB above – surmounting the legs of the wedge – are to be understood as a complex, critical fusing alliance of the attractors A and B – surrounded as this alliance is by threatening states and transformations.

What is pivotal is that this external unfolding opens up, as mentioned, for the study of sequences in systems. An example might be a transcending, vertical cusp in which a sequence, a text, for example, observes a series of transformations: from an ambivalent calm up into a complex critical alliance. This could be a religious metaphysical path[68], which goes from a (horizontal) earthly life up into a union with God:

68. Paths in the control room are introduced by Per Aage Brandt as a semiotic principle in:"La Charpente modale du sens," : "each deformation takes the form of a *road* drawn across a catastrophe (...) and we let this road simulate 'objective' time," p. 15.

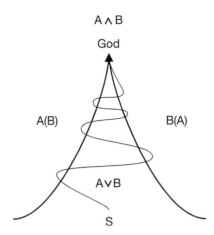

The possible sequences are necessarily manifold; they depend on the material which is invested. What is important is that the material can now be contemplated as a universe, a space in which a movement appears.

It will now be possible to ask: what investment of the cusp occurs in this paper?

In the first place, the thesis is that meaning formation in an aesthetic material is staged by the humanly imaginary. *The elements can be regarded as forms of states connected by phase transitions in the imaginary.* And in this imaginary – which will be examined throughly in the next chapter – the elements will moreover be a material which partly consists of attention structures in this imaginary, partly a schema material which appears as morphologies in the meaning. And it follows from this that the meaning formation is distributed by an emotional and phenomenological attitude to the world, in which the elements appear either euphorically or dysphorically.

These thymes will be the smallest possible morphological material which appears in this meaning formation – and the thymes can be imagined as accompanying the schematically oriented morphologies, such as: the dense as opposed to the diffuse, the near as opposed to the distant. This can be invested so that the thyme euphoria must be thought together with the element water, and the thyme dysphoria in connection with air. This can be illustrated thus:

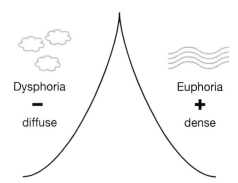

For use in this work I have set up the following pictogram series for the elements:

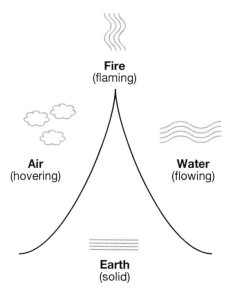

It is noted that earth is found in an ambivalent inner zone, fire at the complex apex (the fiery combines the dense and fluid structure of water with the fleeting and diffuse character of the airy and distant). Water's dense and euphoric material is placed in the right catastrophe plane, air (and the pertaining light) in the left catastrophe plane.

In the second place, a thesis of the *excited imaginary* is developed on the basis of these imaginary investments. This thesis is followed up with a new development of the cusp[69].

The idea is that a given meaning material can be placed opposite a *lower ambiva-*

69. This redeveloping of the cusp - by Per Aage Brandt and the author of the present paper - is the result of a reading of Søren Kierke-gaard's fragmentary text *"Ottevejskrogen"* (the Nook of the Eight Paths), which is analysed below.

lence and an upper excitation, just as this naturally will correspond to a humoral opposition between, for example, being "down" or "up" in the metaphoric sense. This can be formalized in the following topology:

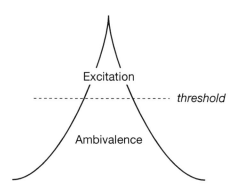

These areas' separation is marked by a threshold which divides the "old" cusp in the middle. And every aesthetic material – and imaginary relating thereto, moreover – will have such vibrant and nervous areas – possibly agitations in everyday life, hallucinations and ecstasies in the aesthetic material, and so on, which comes from an ordinary, ambivalent, neutral area. This can be imagined in this cusp, which is called *the A cusp* (because it is shaped like a capital A).

In any case, the above three-dimensional model will appear as a tool in the analyses. It will view the text as a space, a universe.

What remains now is the question of imaginary meaning formation; here the principle of the A cusp will be further elaborated.

5. IMAGINARY MORPHOLOGIES

Every meaning formation in one way or another is an experience of wholeness. It is said of a good work of art that it was a great experience, something has coalesced in a higher unity for the beholder. How can that be?

The question is: why are isolated details experienced as a continual whole, why does a real world, an art work, appear as a continuity? It shouldn't be like that: the real world is not a continual whole, a field of vision can never contain all the information it is met with (on the street, in the supermarket, etc.), just as a work of art isn't continual either; it happens to be the case that modern comparative literature, aesthetics and so forth, have elevated the question of the fragment, fragmented modernity, to *doxa* – this is naturally only possible because such a thesis of modernity, subject (and object), rests securely on a continuistic and synthetic language – in which such things can be discussed as discontinuity as well as continuity.

This question – which naturally ties in with the catastrophe theory's question of how discontinuity arises from continuity (cf. Chapter 4) – can also be brought into focus in the theory of the imaginary: here the same problem is encountered: how is meaning organized, and more important – how are different semantic universes organized in different contents with different references to different aspects of the imaginary? I repeat: how is a discontinual impression quantity held together so that it appears as a whole in the imaginary meaning formation?

Part of the answer to how discontinuity can be perceived continually lies in the fact that impression information is capable of being dynamic relations that jump between layers – kept together as a whole precisely in virtue of the dynamic jumps themselves – in other words the continuity lies in the dynamic potential, in the sequential possibility.

But what is the imaginary?

Put simply, the imaginary is - first and foremost - *a semantic continuum in human perception*. According to Brandt it can be regarded as distributed in three strata; these strata are significant planes that receive and "interpret" information. The imaginary resembles the theory of cognitive background material in so far as the imaginary contains the same type of stratification thesis – only at a higher level.

With the imaginary there is question of meaning – in a certain sense the imaginary is a hermeneutic instance: the imaginary interprets phenomena from the outer and the inner world, and yet these meanings are stratified in relation to the internal deterministic infrastructure – the elements and the morphologies – so that an (arbitrary) hermeneutics cannot entirely be contemplated.

In any case, the theory of the imaginary resembles the cognitive material in so far

as we are speaking of three strata – *the bio-imaginary, the socio-imaginary and the phan-tasmatic-imaginary*, in that these refer directly to the cognitive "worlds." The impor-tant thing, meanwhile – and with it the difference from the cognitive "worlds" – is that the imaginarity is communicated directly and can be discussed – Jensen says such and such about Ovid's poetry, he means something, this meaning can be classed with, for example, an imaginary meaning content. The imaginary *contains*, whereas the cognitive worlds schematize.

The imaginary is a stratifying of three layers which fold on each other, but this folding occurs in two forms of image formation which simultaneously constitute two topoi: an outer and an inner.

Altogether one can say that this spontaneous metaphysics, which every subject must be thought to be in, constitutes a chorematics[70], which divides the "psychic" into two parts: now something is experienced as being "in" and now as "out." The image formation moves between the perception's outer "shields":

where the sensorily accessible world turns up...[71]

And the ideation's "inner" shield:

where our recollection, our expectations and our contrived ideas turn up...[72]

Is this the "rough" – practically cognitive – framework in the imaginary ('in' versus 'out'), then it is immediately more complicated with the three strata of meaning for-mation. The nude and abstract imaginary can be elucidated in the following graph, where what should be observed, first and foremost, is the form, which I will discuss:

Imaginary stratum

Imaginary stratum

Imaginary stratum

70. See Brandt, 1983, p. 242: "A *chora* (...) *is a locus viewed in relation to a subject.* The basic distinction then becomes the coupling *inner* (being on the locus, in the space) as opposed to *outer* (being outside). When such a subject is identified in relation to a specific chora we may speak of a *chorem*. The chorem gives occasion for a semiotics by appearing distinctly in the two states. Seen from without a chora is a *thing*, but seen from within it assumes the character of *space*. In this sense a chora is a building in relation to which the subject as body characterizes its own position, in that it characterizes the building. In so far as the building is closed the subject finds itself either inside it or outside it, either shut in or shut out: *either - or.*"

71. Brandt, 1991A, p. 89.

72. Ibid., p. 89.

The above is a graphic representation of the (three-dimensional) space in which the meaning, *the imaginary*, can be thought of as becoming dynamic relations and sequences between the three strata, which I will define in the following:

The first and simplest imaginary – the *BIO-IMAGINARY* – or the biological imaginary, is an individual stratum oriented according to elementary significant and cogent categories. Found herein is the stratum of the needs and the instincts; there is question of a private universe based on simple experiences with objects and objects' values for a subject.

One might say that this stratum of the needs and the instincts will moreover appear elementarily cogent in relation to the object's experiences. Isolated experiences of security and danger, the near and the distant, the large and the small, the hard and the soft will regulate this stratum's thymes – again in simple morphological halves: now the world will appear near and euphoric, now distant and – conversely – dysphoric. Viewed cognitively, a framework like to be "in" or "out" of something will be simply significant for a bio-imaginary experiencing subject:

There is a family of OUT-schemes (distal) opposed to a family of IN-schemes (proximal), so that the first type renders the part of perceptively experienced reality where dangers lurk and food waits, whereas the last type summarizes the circumstances of protection and rest. Once more, space is polarized by valorization, dysphoric OUT-space versus euphoric IN-space...[73]

Everything considered, it must be a thesis that it is in this bio-imaginary stratum of the states that we find the morphology's simplest and bearing infrastructure – in so far as this "as-good-as communication independent world of experience"[74] does not register anything but the elementarily cogent and significant.

This is owing to this stratum's experiential ontogenetic imprint: "nearness or distance" in relation to the body will be dominating for later real-world experiences.

And contained in this bio-imaginary stratum is a distribution of the simple morphologies, the euphoric and the dysphoric, so that the latter become a sustaining medium for experiencing the world as form carried by the form related morphologies:

The euphoric will be attached to near sensing; the near, the dense – taste, smell and touch – will be connected with the experience of the body in continuity with the world. A parallel to this is that this ontogenetic stratum has roots in consuming and the fullness belonging to it. The bio-imaginary will give priority to the near senses' tactile contact with the real world – hence it follows that the element "water", viewed semantically, becomes the euphorically experienced form. Hydrology participates in the bio-imaginary because it has a closed form, and perhaps because it is connected

73. Brandt, 1995, p. 232-233.

74. Brandt, 1991A, p. 92.

with the ontogeny's early recollections (caresses' "wavy" character, consuming's diffe-
rent "fluid" absorptions, etc.). Solid objects and "things'" quantity will be modalized
by these thymic and element-oriented logics – either having or not having the latter.
The bio-imaginary will be a stratum which on the whole is regulated by the private
"having" or "lacking" – just as the body finds its underlying stratum in the bio-imagi-
nary (the divided, morselled body etc.).

Conversely, we see in this stratum that the distant and diffuse are established on
dysphoric morphologies. The element "air" will attach itself hereto and characterize
the dramatic, boundless space, the not being in control of the world. A fundamental
"feeling" of distance – of air – will be able to oppose tactility's near "watery" satisfac-
tion. Dynamically the following topology can be a depiction of these phenomena:

If the bio-imaginary stratum refers to experiences and objects and values of objects
then the next stratum is differently organized:

Here the space is not organized by objects, but by what one could call purely formal qualities...[75]

In so far as there is in this *SOCIO-IMAGINARY* stratum (in the earliest edition titled
the pheno-imaginary[76]) question of a common knowable and communicable "world"
and reference semantics.

It is in this stratum that we find the social and common understandable world.

75. Brandt, 1991A, p. 93.

76. See Brandt, 1991 A. - In Brandt, 1991A one also notes that the imaginary continuum is folded like an S. Later this S is then trans-
formed to a G. Everything considered, the theory of the imaginary itself can as theory development be characterized in this way:
step one is Brandt 1991 A, step two is Brandt, 1995, the present paper and the seminar "Elements and Ideas" Aarhus University,
April 1993. This theory furthermore enters into a dynamic semiotics which, for the time being on dissertation level, consists of the
following: Dorthe Mortensen, 1991; This author provides a theory of text concentrated on the semiotics of Brandt's but also taking

In contrast to the bio-imaginary private world the socio-imaginary is an inter-subjective world – this stratum is countered by the cognitive W2 world. And it is in this socio-imaginary stratum one refers to impersonal and formal frameworks for understanding the world as such: one has a "bright" or "gloomy" outlook on life; one talks about the weather, enters into agreements, lays plans for the next "work assignment" – one understands the inter-subjectivity through frameworks and norms, for example, also all the way down to the pronouns (I, you, we, them):

The pheno-imaginary [socio-imaginary] forms the world of our perception-based argumentations; it constitutes their horizon that is accessible to others, their referential basis which also embraces recollections and expectations that are in principle collective...[77]

Viewed thymically, this socio-imaginary stratum is interesting in that there occurs an inversion of values – so that the private euphoric "nearness" now suddenly becomes dysphoric: it is in the socio-imaginary stratum that "the rules of good distance" become norms. This is what one is dealing with when one enters into social everyday connections – it isn't "good tone" to "be pushy" in inter-subjective contexts (at the discussion meeting, on the bus, in the examination situation, etc.). Topologically it can look like this:

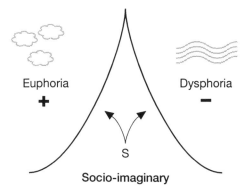

Euphoria
+

Dysphoria
−

S

Socio-imaginary

in a reading of Karen Blixen's *The Dreamers,* a reading which uses catastrophe theory and imaginarity analysis (concentrated especially on the passion analysis). Further, Peer F. Bundgaard, in the paper *Metafor og Billedbevidsthed* (Metaphor and Image Consciousness) 1992, gives a reading of Heidegger, Husserl, Kant and the most recent cognitive science. This dissertation is an attempt to outline a neutral ontology - the subject is the metaphor, which is regarded as being built on a schematism and cognitivism in the concepts of sense. In close connection with this paper on "The Aesthetics of the Elements" I must mention Jahn, 1992; This author describes Cézanne's pictorial space. The method here is strictly dynamic, the aim in this dissertation is to describe the landscape genre in painting (and in it Cézanne): "The landscape is both occasion for a positive passional reaction (...) and for a negative passional reaction, which are prompted by the infinite aspect which is implied in nature. The infinite/finite complex must thus be seen on the basis of the fact that the object-world (nature) which the landscape depiction refers to is incomprehensible to the perspicating subject. But in the landscape work the unknowable world appears as a comprehensible, delimited, perspicuous unity" (Jahn, 1992, p.100). Also Morten Søndergaard, 1993, must be mentioned: this author analyses the concept time in the Argentinian author Jorge Luis Borges going from a dynamic and catastrophe-theoretic way of thinking.

It is noted that the distant senses – the eye, the ear – are given higher priority in context with the element – air – because the socio-imaginary inter-subjectivity – as mentioned – priorities distance, diffuseness and the perspective's open and extended forms altogether: in everyday language, one puts space between oneself and persons or groups; in political life one lays utopian plans for the future (u-topia exactly, which means "no-place").

And finally: while in the bio-imaginary one observes relatively impoverished mood values the socio-imaginary stratum is the place for properly social moods that can be graduated – ranging from the daily comment on the weather (having a bright or gloomy outlook), to social agitations in which groups combat or incite each other. The socio-imaginary could at bottom be described as a collective mood stratum in contrast to the individual thymic bio-imaginary.

The third and last stratum which must be included in this stratified imaginary is the *PHANTASMATIC-IMAGINARY*, or as it is also characterized: *THE EROTIC-IMAGINARY.*

This imaginary belongs to a world of desire, ideas of the other person, dreams and reveries. We are speaking of an individual stratum, where we again find an inversion of distant and near senses so that near-sensing's tactile element – the water – again becomes a euphoric valorizing area (just as in the bio-imaginary), and conversely becomes the distant area – with the element air belonging thereto – a dysphoric area.

The nocturnal tenderness, erotic-physical love, the tactility of caresses whatever, appear to live their lives in this stratum; projections and symbolizings can be imagined as being material which comes from this phantasmatic-imaginary:

symbolic near-sensing such as intense reading (of texts), reading the surfaces of pictorial art, musical experiences etc.(...) follow 'magical tracks' that exploit the tactile in an affective contact with the object – as if it was a body – and by these means sensualize (also with eye and ear) what would otherwise appear practically abstractly...[78]

In this way thinking and analysis become a phantasmatic figure, in so far as both thinking and the erotic-affective reconnoiters a basic notion of the other as something that is hidden, a reality that must be brought to light. The erotic-phantasmatic altogether reconnoiters a continuistic "being" behind the salient and possibly discontinual, and:

The experiences are 'inner' but, paradoxically, their import is outer, as being 'about' the phenomena displayed by the other worlds. Any fantasy, idea, model, or thought is in fact *noumenal* in this sense, and must refer to reality-behind-perception, being-behind-appearance. Even erotic extasis 'refers' to some sort of hidden truth or deeper reality (...) The analogy of an erotic quest for union and an intellectual quest for

78. Brandt, 1991A, p. 97.

79. Brandt, 1995, p. 234.

solving a problem is constitutive.[79]

That the phantasmatic-imaginary has the element water as form and euphoric morphology, and conversely "the airy" as dysphoric morphology, gives the following topology:

The above three different organizations of the same imaginary basis material in thymes and elements give naturally three different strata. This gives occasion again to take up the question from the introductory theses: how can it be that we still only experience the world and meaning in the world in one and only one plane at a time? You wouldn't think so if you take the theory at its word, where – as shown – the argument is in favour of three strata. A Brandtian theory is that this imaginary is dynamic; it can either be connected through abrupt change-overs *(switching)* or through foldings in which maps lie down on maps *(mapping)* – in other words, movements which calmly merge into each other.

But, first and foremost, the theory of the *trans-imaginary's* structures must be understood within a continuum:

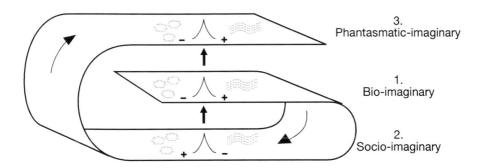

This continuum, in shape like a capital G, shows the theory of the imaginary in a total version. The G contains a depiction, a landscape, in which are found the different strata.

The dynamics in the G show up in two ways: first through change-overs or mapping, respectively in a bricolage within the different strata – bio-imaginarity merges into socio-imaginarity and subsequently into phantasmatic-imaginarity (see the arrow inside the graph) – or also through abrupt change-overs between strata (indicated by the arrow outside the three strata); but secondly the dynamics is readable in the three stratas' internal distributions of thymic morphologies and elements (indicated through the small cusp on each stratum, where values and elements must naturally be understood as dynamic attractors). These dynamics are relations which must be imagined in relation to each other, in that the relational movement itself is the argument for our experiencing the world in one and only one plane at a time. And it is possible to visualize that in those cases where the relational connectedness itself and the potential for dynamic jumps or continual mergings between the levels is lost, that is where we are dealing with anomalies (psychoses, schizophrenias and so forth). An interesting (and hasty) intuition on the G would be that precisely the anomaly is characterized by a rigid perception of the real world: as though the anomaly congeals in, for example, the phantasmatic (in the notions of paranoia – air-dysphoria) and is incapable of changing over to, for example, the socio-imaginary's rationality or the bio-imaginary's bodily experience.

This G can now be further applied as an operative model in the aesthetic analysis. For use in such an application I will stylize this G so it acquires the following shape:

The point is merely the stylizing of itself in the G. It is simply easier to depict in the analyses.

But the actual point, meanwhile, is that this stylized G becomes applicable as a possible model for different investments.

One can visualize different types of investments. One type could be the temporal

figure in which the socio-imaginary will correspond to a series of events that take part in the presence, while the bio-imaginary will correspond to the experience of a past, and the phantasmatic imaginarity will correspond to the notion of a possible future. The temporal G will look like this in a nude form (and this is henceforth imaginable as a sequence – naturally on the basis of the aesthetic material):

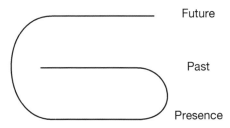

Another type would be the vertical G, in which an aesthetic material seeks away from the socio-imaginary "reality" in order to be realized in an ideational universe which can be imagined as being 'more true' than the socio-imaginary "reality." This is – as is known – a metaphysical figure which has deep roots in modernity, antiquity – and on the whole in different forms of religious metaphysics: The divine can be imaged as a hidden and true figure which is attained through an elevating, transcendent movement from a "false" socio-imaginary reality to a "true" phantasmatic reality:

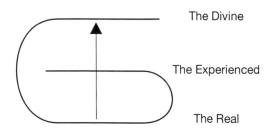

- where one could say that this vertical figure intersects bio-imaginarity (the experienced) because it will be here the aesthetic praxis or the religious liturgy – also as praxis – functions as a tool for the possible transcendence and divine "fulfillment."

Conversely, the figure for a "revelation" or an epiphany would be a descending vertical movement – something comes down to a subject, the divine materializes as a divine "grace," "inspiration," or precisely "revelation" in the socio-imaginary reality. Something is suddenly opened to a subject or a religious group:

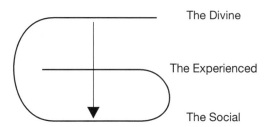

The Divine

The Experienced

The Social

The above figures can be imagined as being contained in the (stylized?) and widely used subject-object category, the category which viewed philosophically becomes a triad if the notion of *being*, the non-salient (and phantasmatic), is invested:

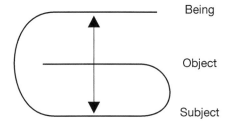

Being

Object

Subject

I show these relations with an arrow in both directions so as to mark the mutual relational connectednesses.

A final type which I will mention is the figure for thinking, a figure which is reminiscent of Merleau-Ponty's total intentionality (cf. Chapter 2):

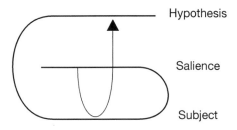

Hypothesis

Salience

Subject

The movement must be imagined as taking its point of departure in a material, something salient which is apprehended by a subject and becomes a possible notion, a hypothesis, a thought.

The possibilities are necessarily manifold for such types of investments, invest-

ments which must have a material at hand, something salient. I will leave off the G for a moment while I now reply to the question:

In what sense can this theory of the imaginary be thought to reproduce a phenomenology?

Here it is possible to carry on with the thesis of the Merleau-Pontian total intentionality, by means of which a connection is suggested between an imaginary and a phenomenology in such a way that a phenomenology is a theory of the imaginary *and vice versa*.

And likewise it is possible to elaborate the thesis of the A model which we left off in the previous chapter.

Beyond that, these two argumentations will provide a renewed point to the question as to how it can be that "one experiences something as being a whole."

The idea is that an aesthetic material (and any act of perception whatever) stages imaginary meaning formation through a fundamental emotional relating to the real world, in such a way that one can speak of an existential attitude to the world divided between two zones: *one of them experiences the beautiful, the erotic, existential nature etc.; the other experiences the isolated, the "empty," the humdrum, the pragmatic, – or simply the excited opposed to the ambivalent.*

This has already been mentioned – or suggested – in the previous chapter in the question regarding the A model (p. 49).

With the revised groundwork surrounding the imaginary and its strata it is now possible to invest the different strata in the A model, so that the theory of the imaginary can be invested. First the model:

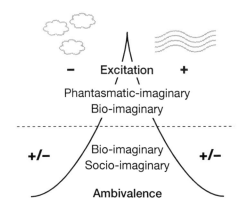

We note that the bio-imaginarity is placed both in the lower and the upper zone. This means that *bio-imaginarity is the bearing substratum for this compact theory.*

That it is connected with the role which bio-imaginarity plays in the theory as

being the bearing and individual, private stratum whence we can imagine a theory of the aesthetic in the imaginary and the imaginary in the aesthetic. Bio-imaginarity constitutes this type of smallest possible humanly imaginary, in so far as this stratum functions as substratum both in the socio-imaginary and in the ideationally phantas-matic; in that way that the social space, the socio-imaginary "reality," consists of sub-jects which have experience of themselves and are in conflict with the real world, and in that way that the phantasmatics rests on the primary objectal experiences from the bio-imaginary (one actually speaks of objects of desire: they are those which consist of an ideational content but on the basis of a bio-imaginary object: a body, a fetish etc.).

From this follows, then, the decisive thesis that the aesthetic expression observes a movement in which it endeavours to get free of the socio-imaginary reality; the thres-hold between the two areas marks the transition from what would be the lower profa-ne area of conflict and the upper "sacred" harmonic area. In the mathematic internal space, which is thought of as underlying this new control space, it means that the valu-es in the upper area will be nervous and excited, whereas the values in the lower will be slow and ambivalent.

There is nothing new in this; art, aesthetics and metaphysics are familiar with such, at bottom, transcendent movements. What is new consists in the language in which it can be spoken of.

And the A model can depict a universe – an aesthetic universe – where such dynamic movements can be shown in a topology *controlled by morphologies and ele-ments.*

The A model shows a basic "down-up" or "up-down" orientation in the aesthetic expression – an excited, existential nature or art experience up over the ambivalent, humdrum socio-imaginary sphere.

And the union in the excited area – between bio-imaginarity and the phantasma-tic-imaginary – will be this:

phenomenological scope, by which the world of bio-imaginary perception becomes the stable standard set-ting, reinforced by the phantasmatic projection in aesthetic excitation (...) that opposes in all instances the privacy of the isolated Self and the communitary perspective...[80]

The phantasmatic becomes a guarantor for the excitation of the bio-imaginary basis, and vice versa: the socio-imaginary becomes an area of conflict for the private subject.

This type of theory is a formalizing of a number of relations in a "hard" language which, when all is said and done, functions softly universally:

From the experience of the beautiful in nature, art, the erotic, in which the expe-rience of beauty itself is effective in virtue of the phantasmatic projection of a content,

80. Brandt, 1995, p. 237.

which for a moment seems one of excitation and abandonment compared to the "humdrum daily grind" – *to* our everyday language, which without further ado associates with these excitation and ambivalence logics.

Merely take the last five lines: one speaks of an *experience of beauty*, something is up, the mind or spirit is exalted (in relation to something down or dejected); just as also one speaks *precisely* of the "humdrum daily grind" with its mechanical, abrading monotony and milling humanity; remarkably, one does not speak of daily life's "pirouette" or "tango," for there we wouldn't have the same socio-imaginary "reality" in our ears.

In summary, a simple existential experience of nature will have this possible movement (cf. especially the following analysis of a text from Kierkegaard):

By means of which one regards the bearing bio-substratum moving from a lower up into an upper plane[81]. And exactly the dynamic movement – carried on a bio-body but installed in different spaces, makes it possible for the theory to be understood in one and the same whole, on one and the same plane at a time. *The bio-imaginarity guarantees this.*

In conclusion it would be appropriate to comment on the following use of the theory in the analyses. In this way:

Firstly, the G will be used as possibly overriding sequences in the aesthetic object. It means that this G will be used as a sequence model seen in a two-dimensional plane.

Secondly, I will use the A with the imaginary embedment as a three-dimensional universe, in which it is possible to follow the sequence in its detailed points and movements through the sequence – phantasms, socio-imaginary frame, etc.

81: Note: in the following analyses I will omit introducing the different terms from simple considerations of space. However, *the models presuppose these terms*. Moreover, in the following the analyses refer to the text and picture enclosures. As regards the text enclosures I refer to the lines, whose numbers are given in the margins.

Following this is an interpretation strategy which at bottom can be thought of as being thus: First the text will be analysed in relation to the course it takes, and I employ the stylized G in order to show this course; then follows the A's universe. One could say that the stylized G's course is two-dimensional; it is movements imagined in the G's allocation of strata, but it is shown within the framework of the "abstract" theory.

Conversely, the universe in the A is – as said – understandable as a three-dimensionality. Here one sees the G's movements – now added in relation to the elements' placement in the catastrophe surfaces. And there exists the following graphic corollary between the G and the A:

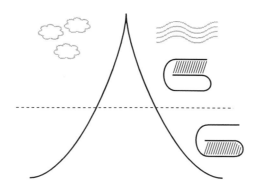

The G is – as seen – placed in relation to the A cusp's universe – and vice versa: The A is placed in relation to the G. The relation between the A and the G is as follows: the G will constitute the imaginary's genotypical and determining genotype; conversely the A – seen in this context – will constitute the phenotypical phenotype. The A will be the topological result of the G's anlage. The hatchings in this compact model indicate the alliance between the bio-imaginarity and the phantasmatics in the upper "sacred" area and the socio-imaginarity in the lower "profane" area.

In concluding it should be noted that I do not employ the stylized G in the two picture analyses. It isn't necessary, as a picture as such is built on the perspectival sequence of the whole – an immediate universe equivalent to the A.

6. TEXT AND PAINTING

1. The Languorous Sky

The reason I cannot really say that I positively enjoy *nature* is that I do not realize *what* it is that I enjoy (...) The works of the deity are too great for me; I always get lost in the details. This is the reason, too, why people's exclamations on observing nature: 'It's lovely, tremendous etc.' – are so frivolous. They are all too anthropomorphic; they come to a stop with the external; they are unable to express inwardness, depth.[82]

Kierkegaard's doubting between both "enjoying" nature and being "sceptical" towards language and science, which talks about and tries to apprehend nature, concerns the relation between nature and existence, the divine and the human. The doubt carries far, and affects the inner workings of the very condition for cognition being possible.

Thus does the Kierkegaard scholar Arild Christensen trace doubt in Kierkegaard, in a model lecture on the relation between Kierkegaard and nature.

In this lecture he shows us Kierkegaard's background in Romanticism (Novalis); Christensen likewise goes even further and describes backgrounds in antiquity (Plotinus), in the Middle Ages (Jacob Boehme), in mysticism (Swedenborg):

With Novalis, who appropriates to himself both Boehme as well as the Neo-Platonists, the exposition arrives at the spiritual area from which the clearest influence from Kierkegaard emanates. As early as with Wackenroder there exists the notion of a Nature made independent, which communicates itself if in no other way then by atmosphere: 'We know not what a tree is; not what a meadow or a rock is; we cannot speak with them in our language...and yet the Creator has implanted in the human heart such an odd sympathy with these things that they by obscure paths convey to us feelings or states of mind, or whatever one would call it, which we do not obtain with even the most scrupulous expressions in words.[83]

And in a learned *tour de force* Christensen runs through this history of influences, likewise naturally Kierkegaard's dilemma: that man is separated from nature; that nature is no longer possible *for cognition* as a place for an aboriginal (romantic) synthesis, *but* still nature is present; existential nature has an effect in the subject. Christensen arrives at the conclusion that the impression of nature becomes metaphor and comparison, just as it becomes a mood, a feeling. Christensen makes Kierkegaard a nominalist, nature is an elemental cipher in man, a figurative language.

I will not go into details with this far-reaching theory, just as neither will I place Kierkegaard's dilemma in relation to the current stratificational thinking in stages – the ethical, the aesthetic and the religious.

82. Kierkegaard, 1967, p. 50.

83. Christensen, 1964, p. 19.

I would rather act as if these influences and these philosophical implications did not exist, and instead concentrate on the dilemma: why does nature act existentially on a person? What is it about external nature that is effective, and has the effect of a feeling? What are the obscure paths that convey to us feelings or states of mind?

And I will naturally assert that the feeling and the state of mind are built upon the imaginary's stratifications. This entails a type of phenomenology which purely and simply revives the feeling – *an sich* – as the instance which constructs cognition and interpretation of the real world.

Kierkegaard's notes concerning nature are scattered throughout the authorship; also the following excerpt – "the Nook of the Eight Paths" – which can be regarded as a narrative within a larger narrative, "In Vino Veritas," which appears as a recollection "subsequently related by William Afham"[84]

Meanwhile, Kierkegaard's lovely landscape description "the Nook of the Eight Paths" constitutes a compact whole in prose poetry. It is called by Christensen the most beautiful landscape portrayal in Danish literature.

The place is Gribskov forest north of Copenhagen in late afternoon. A subject finds itself in this landscape alone with his thoughts and feelings. And the location where this takes place, "the Nook of the Eight Paths," is depicted as being indefinite. The I is disoriented in the literal sense:

In Gribs-Skov there is a place called the Nook of the Eight Paths; only the one who seeks worthily finds it, for no map indicates it. Indeed, the name itself seems to contain a contradiction, for how can the meeting of eight paths create a nook, how can the beaten and frequented be reconciled with the out-of-the-way and the hidden? And, indeed, what the solitary shuns is simply named after a meeting of three paths: triviality – how trivial, then, must be a meeting of eight paths! (lines 1-7).

Here, at the beginning of the text, this place is depicted as a trivial place, a dysphoric topos. But later the same place is described thus:

it is also true that everything heard and to be heard in the world sounds most delectable and enchanting heard from a nook when one must contrive to hear (...) when the autumn sun is having its midafternoon repast and the sky becomes a languorous blue... (lines 32-38).

What has happened? How has this dysphoric trivial place become such a delectable and languorous place?

As we see, the text has undergone a transformation – in strict catastrophe-theoretic terms a transformation of state, a phase transition from dysphoria to euphoria. The feelings for the place are changed, but the odd and completely banal thing which the

84 . Kierkegaard, *Stages on Life's Way*, 1988, p. 16 - 17.

subject (and the analyst) knows is that the place is the same, except for one thing: the subject sees something else. What is it, and how is it constructed?

I will divide the text's space into two main parts. The first part runs from the beginning of the text and on to line 28, where the transition is marked by a dash, after which it reads: "If what the poet says is true..."; from here we have the second part, which continues for the rest of the text.

These parts give, as the first consideration, a section which deals with the I's ambivalent feelings towards the place, and a second section which deals with the I's excited and ecstatic feelings for the place.

En route in the text one subsequently finds an overriding imaginary sequence which can be stratified in the stylized G:

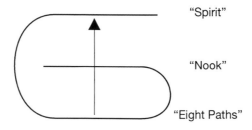

"Spirit"

"Nook"

"Eight Paths"

The above G describes the overriding stratificational sequence between imaginary strata. What we see – following the arrow – is a movement from a socio-imaginary "reality" into a bio-imaginary concentrating on the individual and further up into an ideational space: the phantasmatic-imaginary. The text shows a vertical movement from materiality to immateriality running through the subject's "nook."

The ascending principle follows the text thus: the socio-imaginary stratum is described as trivial (line 7), it is solitary and out of the way, it is:

close to a forest area called the Unlucky Enclosure (...) The eight paths – heavy traffic is only a possibility, a possibility for thought, because no one travels this path except a tiny insect that hurries across *lente festinans*. No one travels it except that fugitive traveller that is constantly looking around, not in order to find someone but in order to avoid everyone... (lines 9-16).

The socio-imaginary stratum, viewed semantically, is a locus which is in conflict with the subject in the text. A conflict which is constructed on a fundamental thymic conflict between the individual and the collective. Even in the first lines of the text this conflict is shown in the very pivotal question in which the I inquires into the name itself of the place (the Nook of the Eight Paths):

Indeed, the name itself seems to contain a contradiction, for how can the meeting of eight paths create a nook, how can the beaten and frequented be reconciled with the out-of-the-way and the hidden? (linie 2-5).

The nook in the text belongs to the stratum of the bio-imaginary. Topologically the nook is a snug place, a cubbyhole, a hideout for the bio-imaginary body. The nook is a projected bio-imaginary topos – a place where society and reality necessarily can't get in. In cognitive terms it would be a container or a chorem.

The conflict in the text exists between this snug, individual nook and the greater "society," the eight paths, expressed distinctly also in the fact that in the first section the speaker is a "one," whereas in the second section an "I" proper is introduced.

The nook is present from the text's beginning until its conclusion – in both parts, mind you. In the second part, however, it is present in another and euphoric way; it is now also the I's nook (line 29), just as it is ascertained:

Is it certainly true that the world and everything therein never look better than when seen from a nook. (lines 30-31).

The nook is the sustaining substratum throughout the text (as will be seen in A, shortly).

Meanwhile, the text changes character fundamentally. The whole text is rounded off in an excited, ecstatic and phantasmatic eulogizing:

O friendly spirit, you who inhabit these places, thank you for always protecting my stillness, thank you for those hours spent in recollection's pursuits, thank you for that hiding place I call my own! (lines 46-48).

The text, with such a statement, is elevated to pure paean, to a fundamentally phantasmatic vision of spirits, of the divine; a bio-imaginary and phantasmatic-imaginary which in union now calls "the Nook of the Eight Paths" a hiding place.

What role do the elements and the morphologies play in this text? I will project the text's topology and imaginary strata onto the A's universe:

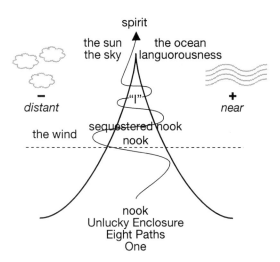

And the text is now intuitable as a universe invested in what one must imagine as being a three-dimensional representation.

The attractors are elements and morphologies; the sequence through the text can now be perceived in this manner:

In the lower zone – in the area of conflict between bio and socio-imaginarity – the text's "Unlucky Enclosure, eight paths and nook" are invested as meanings which here are ambivalent. The ambivalence attracts logical and cognating thought. I have already shown how Kierkegaard has to turn the place over in his mind as "a meeting of paths." One could say that logical and cognating thought is based on geometric and mathematical speculation, "for no map indicates it" (line 2). The place is a contradiction among possibilities, "a possibility for thought" (line 12). The fundamental ambivalence concerns thought itself's possibility of giving a name to the place: "the name itself..." (linie 3), "the name only makes..."(line 10). To be not able to name the place is an ambivalence.

This ambivalence threatens the subject in the text. The ambivalence is shifted up over the threshold. The conflict is excited, and the element "the wind" is mentioned:

No one travels this road except the wind, about which it is not known whence it comes or whither it goes. (lines 19-20).

It is remarkable that in the preceding lines there is question of direct threats to the body: "the fatal bullet" (line 18). The wind is a displacement of this threat in so far as it – morphologically – is the distant, a suspended loose form. Thymically it is also dysphoric. Now the bio-imaginarity is excited in a union with the phantasmatic-imaginary.

The thought of the place changes character – at first with humour's phantasmatics:

Eight paths and not a traveller! Indeed, it is as if the world were dead and the one survivor were in the awkward situation that there was no one to bury him, or as if the whole tribe had gone off on the eight paths and had forgotten someone! (lines 25-28).

From this point on the text is changed into a highly excited ecstasy with the bio-imaginary nook as a safe point of departure from which the distant senses register the surroundings. The I listens and sees, this distant sensing is "delectable" and "enchanting." There is question of a union of the distant senses and the phantasmatic: that something is enchanting builds upon the magical, the wonderfully state-altering.

The subject senses the real world. This real world consists of elements – now sensed from a sequestered nook. The phantasmatic and the bio-imaginarity becomes more and more ecstatic and excited:

but it seems most beautiful to me now when the autumn sun is having its midafternoon repast and the sky becomes a languorous blue when creation takes a deep breath after the heat, when the cooling starts and the meadow grass shivers voluptuously as the forest waves, when the sun is thinking of eventide and sinking into the ocean at eventide (...) when just before taking leave they have an understanding with one another in that tender melting together (...) O friendly spirit... (lines 37-46).

Such a paean to beauty is erotic, phantasmatic and morphologically complex – both as schema and as thymic; and, first and foremost, this excitation is established on the elements. The beauty and eroticism of the text is established on the elements' morphological material.

There is question of a paratactic finale in which the elements nervously vibrate between the morphologies – expressed, for example, in the line: *"the sky becomes a languorous blue"*. Here one sees the distant, the sky, combining with the erotic phantasmatic near: that something languorously yearns expresses "watery" tender feelings, it is bio-imaginary and phantasmatic (but one can also languish, which would constitute the dysphoric opposite: to starve, for example).

This parataxis – with "when"/"when" constructions that emanate from "but it seems most beautiful to me now" approaches the delirious. One might ask: how can it be that the sea comes into the text: "when the sun is thinking of eventide and sinking into the ocean at eventide" (lines 40-41) – when it is now known that we are in the forest? The question could appear banal, conceivably the subject sees a bit of the ocean on the horizon. Only it is remarkable that there haven't been more indications of this ocean earlier in the text. And for that matter it is immaterial, for the text has use of the near, watery flowing in order to achieve its resolution.

With the sun and the ocean there is question of the same basic union as in the

example with the sky. The sun and the sea are made of the same schema morphologies and figurativeness, they resemble each other in their flowing character. The sun's light sparkling on the water is akin to the flame's flowing form, and the ocean is flowing. Morphologically it is merely a question of differences in substantial forms: the sun's light is more diffuse, the ocean's water is more dense.

It could be added that the text can only be concluded one place if the excitation and the ecstasy are to be rounded off.

And here I am thinking of two things: firstly, there is mention of "that tender melting together" (line 44), secondly, the spirits are invoked. The tender melting to-gether belongs to the elements' complex union of forms and morphologies, just as we are speaking of a union of bio-imaginarity with phantasmatic-imaginarity, a union of body and idea.

This is not enough, meanwhile. With the invocation of the spirit the transcen-dent meta plan is introduced: constructed on the idea but buttressed by the elements' morphologies and thymes, together with bio-imaginarity. Michel Serres endeavours to trace the spirit as etymology in this manner:

Spirit. The spirit comes from the Latin *anima,* which in turn comes from the Greek *anemos,* which is to say the wind.[85]

The wind and the animal, the idea of the spirit as a union of the immaterial distant and the animal bodily: that is the text's meta-plan.

What have I said in the above interpretation? With the two investments in the stylized G and in the A universe I have indicated a phenomenology in the text the emotional attitude of which is borne by the bio-imaginarity.

Basically, the text deals with the nook, that is, the individual in relation to the collective, the socio-imaginary.

The interpretation's thesis is that this phenomenology is based on a conflict, and that the bio-imaginary seeks a union with the phantasmatic so as to transcend this conflict. One observes the two zones' different emotional "making note of" the nook as meaning. From the impersonal "one" of a framework subject to an individual and characteristic persona "I" in a sequestered nook. And one notes the oscillating up through the A.

In this phenomenology, the elements and the morphologies become exactly the aesthetic material which runs its course in the text as the basic substratum for the text's endeavour: *the cognition of the beautiful.* This cognition is based on an oscillating movement.

It is the elements and the morphologies up in the A's "top" that makes the text's

85. Serres, 1985, p. 187.

cognition of the beautiful, associated with the erotic, possible. And then the metaphor "the Nook of the Eight Paths" and the dynamic conflict in the progress of the text be formed in such a way that thought can cognate the beautiful, a bio-imaginary and phantasmatic hideout: *"thank you for that hiding place I call my own"* .

2. Nature's elemental parts: The Dune Mirror

The cosmos is ice and fire and the poet must, in Bjørnvig's words, go through an annealing process in vast, universal nature's extreme contradictions. It is possible solely in virtue of the artistic will to form. In that regard, Bjørnvig's errand is a clear extension of Schiller's and subsequently Nietzsche's attempts to reconcile themselves to nothingness through the aesthetic.[86]

Such is the wording when a historian of mentality (Mortensen, 1993) draws a line through Danish nature poetry with the intention, among other things, to analyse Thorkild Bjørnvig's *"Klitspejlet"* (The Dune Mirror) from his collection *Figur og ild* (Figure and Flame) (1959).

A historian of mentality would subsequently regard the early verse of Bjørnvig as, for the most part, representing a nature-metaphysical tradition, in which nature and cosmos may be given up as a lost paradise but nevertheless not rejected outright as a topos for writing.

How is this so? Why write about nature when the latter doesn't contain any properly atoning answer anyway? To this the historian of mentality replies that nature as "ice and fire" contains the constant sublime horror which corresponds to modern life. And nothingness must be combatted with nothingness.

Meanwhile, the question is whether a reading of that sort doesn't merely replace an older attempt at atonement with a new one, a nothingness's or a negative transcendence, the way Hugo Friedrich[87] describes the structure in modern poetry.

The question must at bottom be posed thus: how can it be that nature and landscape cannot be separated from a sensing I, and can this, if it is true, be due to the fact that the elements and their morphologies are the essentially meaningful material in the imaginary strata?

In terms of composition "The Dune Mirror" falls in three parts. The first part is comprised very simply of the line: "In a place far inside I found...," the second part runs from there to and including line 26, the third part from line 27 to the end of the poem.

86: Mortensen, 1993, p. 259.

87: Friedrich, 1987. For an example see his chapter on Baudelaire p. 28-52.

As a poetic opening the first line is interesting, because on one hand it hints that "something" is going on in an "interior" while simultaneously this interior, consistently through the poem, then employs an exterior, an outer topology, the dune mirror, in order to describe the interior. This "inner" becomes excited by the outer. The dune mirror becomes excited via the macrophysical and realistic outer topos. "The Dune Mirror" is:

perhaps a cosmic mirror which captured everything/and gave nothing back – than for the mind/ which scarcely saw, was but shaken by certainty/of baseless horror, of inexplicable rejoicing… (lines 12-15).

"The Dune Mirror" is a delimited exterior which, however, plumbs the depths. A dune mirror assumes the form of a cone. In the cone's descending form the beholding subject is excited by the dimensional transformations; the gaze is attracted in constant vertigo. The cone's form becomes imaginary, it stratifies the mind and affects it passionally on account of the attraction of the form itself:

its emptiness,/dazzlingly white and pure, touched me/and drew my gaze in constant vertigo down/to the bottom, to the empty cone's point, (lines 6-9).

This dizziness in the gaze and the feelings is confronted with something between surface and space. The gaze is not purely three-dimensional or purely two-dimensional, it is confronted with the feelings' imaginary dynamics which repose on something between perception and ideation.

The course of the poem can be stratified in the stylized G thus:

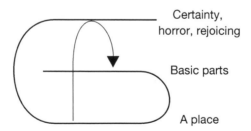

The above sequence model describes a movement from the establishment of the place in the socio-imaginary space, across the mentioned dimensional transformations, on to an ascertainment of the body's (bio-imaginary) fundamental parts:

an eddy which becomes visible and gets power/when flesh and wood, metal and stone have crumbled/basic parts: the vortex's mask, expression, matter – (lines 34-36).

The sequence can be described as the elementary's figure. The I in the poem is forced out over reality's "rim" into a series of emotional and passional states in "a panic death-ly still midday hour" (lines 1-2). And en route in this panic (panic is characterized by a fundamental discontinual "out-of-body excitation") the I is excited in different ways partly by the elements and partly by the imaginary strata – *on* to what one could say becomes the poem's experience: a concentrating on the least possible, the eignbody's parts.

I will depict the following universe in the A:

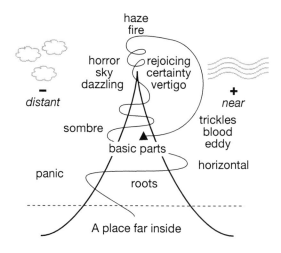

And we see the poem's two catastrophe surfaces – the water and the light – invested with the thymes – euphoria and dysphoria – (indicated by their values +/-) and the schema morphologies: the near and the distant.

I will submit a (comparatively pedantic) word-for-word analysis: the text begins in the area of ambivalence, in the union between reality (socio-imaginarity) and the individual (bio-imaginarity). The poem is sent – as shown in the sequence – out over this rim and is invested phantasmatically in a panic. Even in relatively few lines the dune mirror is in an excited and nervous vibration – built on dysphoria and the light's catastrophe surface. What is spoken of is a "deathly still midday hour." Hereafter the poem moves in a vision of the text's first properly firm, substantial effects: "roots twisted like vipers" down on the ground. The roots can be designated as bio-imagina-ry, ideational matter. Subsequently the text describes the sand mirror as "horizontal." In the adjectival "horizontal" [Danish: *vandret*] the text touches on the element water; it is a question of registering the horizontal topos, in which sand can imitate waves (in a congealed form).

From there the text is again drawn into a notion of the place as sombre, which implies a reference to the light's surface, the dysphoric. And from and including this point the text finds itself high up in the universe. From line 5 to line 26 there is question of a "real excitation" with powerful oscillations – which is also supported by the text's formal structure with short relative clauses which pile up in an unbroken construction.

"The dune mirror" is "dazzling," its light is consequently exceedingly powerful and threatening, but it produces harmonics and acts as a near and euphoric, erotic vertigo, whereupon the text oscillates up into a complex alliance where fire is mentioned (fire is both the airy soaring and the watery undulating). A thesis would be that this dazzling/vertigo must attract an alliance of a complex kind in order to be bearable to the highly excited subject in the text.

Subsequently the text diminishes in intensity a little – dropping down from the divine fire to the sky. And again the text is set to "oscillating," in so far as it is shaken by the phantasmatic's "certainty," something is on the way to being seen through.

A certainty, meanwhile, which first acts as horror and then as a rejoicing: "of baseless horror, of inexplicable rejoicing" (line 15). This extreme state of oscillation is once more transcended by the elements. The text speaks, in line 18, of a haze from "the mirror's bottom." The haze is a complex alliance of, on one hand, the airy, and on the other hand of the watery.

The text is now so highly excited by the phantasmatic and the elements that it has to invoke time: something is to bear fruit "in a thousand years" (line 20). And it is the phantasmatic which in itself invokes the future's perspective. And following this the text mentions fire – a new point of alliance which, however, marks a break in the text.

A break which denotes a transition from the complex element areas to a concentration on the concrete place and the body's blood.

The place is described as based on a trickling: "Unchanged, sand trickles, slips, drifts" (line 27). Here there is naturally question of a reference to water. And from there it isn't far to a linking up to the blood.

The text oscillates into a concentration on the bio-imaginary – on top of the violent phantasmatics in the foregoing. The I of the text is also mentioned – in that there is a triumphant bio-imaginary finale:

a hanging poised in my blood/which the blood does not forget, regardless/of whether I decay, am slowly broken down -/a cornerstone to the world, placeless/and all places possible, regardless -/an eddy which becomes visible and gets power/when flesh and wood, metal and stone have crumbled,/basic parts: the vortex's mask, expression, matter – (lines 29-36).

This (overly?) triumphant exeunt emphasizes the near's euphoric body as concluding the text. However, what is remarkable – once again – is quite simply that this near-ness's shape, referring to concrete parts (flesh, wood, and so forth), has to enlist the help of the outer topos in order to explain itself, just as the elements also are and must be present.

Thus, for example, in the line: "a hanging poised in my blood" (line 29), where there is question of a phantasmatic transfer from the foregoing's highly excited element material. The hanging poised (air), whose tendency goes towards vanishing, is contained and enveloped in the body's bound blood.

The question then is whether with such an ending the following (very grandiose) mentality-historical conclusion can really be given:

The hanging poised takes place in the blood. It is in the body's elemental nonwill-determined functions that the I is a part of the cosmos. The individual is therefore merely a mask, and as such a fortuitous appearance of the vortex which is the lasting. As we have seen in Johannes V. Jensen and Thøger Larsen, for example, reconciliation with nature's nothingness aspect presupposes a relinquishing of the individual I as the measure of all things. By, in this special sense, transcending the I the transcendence is preserved, and with it the possibility of nature metaphysics.[88]

The above historic-hermeneutic analysis views "The Dune Mirror" as a relinquishment of the individual, but a conclusion of that kind is supported, for example, by an exposition of a romantic, nature metaphysical outlook, or one which is decidedly religious: "in which the old Titans attached themselves to the I consciousness's sovereign emancipation from the things of this world"[89].

In addition to which it must be asked: why is this way out less individualistic, even though it regards itself as being a mask or a (bio-imaginary) basic part? One can rightfully – and, at bottom, naively – assert that it is precisely a question of an emphasizing of the measure of all things, in so far as it is a question of basic parts – and the I is surely a component of these pasic parts.

Whatever else, the above topological interpretation of "The Dune Mirror" is supported by the text's imaginary stratification, and by the morphological schema material and thymic material of the elements.

Together this material forms the poem's aesthetics. This aesthetics is *immanent and not historic, as it makes use of meanings that are given with the elements and the morphologies* – where the rhythmic state of exchange which asserts itself (of baseless horror, by inexplicable rejoicing) is the means whereby the poetic formal material must speak.

And it could be added that the external topological anchoring (the dune mirror) is the necessary three-dimensional space which is organized by the imaginary strata.

88. Mortensen, 1993, p. 260.

89. Mortensen, 1993, p. 260.

The poem's far interior, its roots and its basic parts, are imaginary representations of the real (socio-imaginarity in union with bio-imaginarity), which are excited by the sight of roots in a series of tremors down through the poem (bio-imaginarity in union with phantasmatic-imaginarity), to discover at last the idea's "basic parts: mask, expression, matter -." Observe that the poem mentions matter in the last line; what is being spoken of is poetic matter, the aesthetic. The subject of "The Dune Mirror" is two things: *this aesthetic material and the imaginary mind. They are the same – held fast by the material: the elements and the morphologies.*

3. Light and Water. Angel and Fire.

In 1846 J. M. W. Turner (1775-1851) paints an angel, a serpent, a group of birds and two groups of people. The angel is situated in the middle of the picture, the birds are in the top left corner, the two groups of people – with four persons in each group – are standing or lying writhing in agony in the lower part of the picture on both sides of the serpent, respectively in its lower right and left corners. The angel is the picture's midpoint; he is holding a staff in his right hand; the staff is pointing up towards the group of birds; the angel's gaze is upwards; it is focused neither on the birds nor on the people, the gaze is directed out of the picture; the mouth in the face of the angel is slightly open. Turner titles this picture *The Angel standing in the Sun.*[90]

And compositionally the picture constitutes a sun figure, in the choice of an orange-yellow color which dominates the centre and is slowly transformed to a deep orange in the lower part and to a golden yellow (with blue and white) in the picture's upper part. Finally, the reference to the sun figure is readable in the elementary pictorial form: the picture is constructed like a circle running centripetally from the outer edges in towards the angel in the axis of the centripetal force. The picture is nervous and dramatic in virtue of this centripetality, and it is dynamic, rhythmic, in virtue of the brushwork's oscillating and slightly scratchy character. The picture can be characterized in the following manner:

90. See appendix.

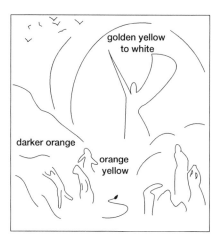

There appear three fields in the picture: a first, lower field of people, a second and "inner" field with the angel and a third field with the birds.

The Angel standing in the Sun is one of the last pictures in Turner's enormous production – it is intertextually connected with the picture three years earlier "Light and Colour (Goethe's Theory) – The Morning After the Deluge – Moses Writing the Book of Genesis" (1843); a picture which compositionally is based on the same circular turbulence inward into the picture, just as it is based on the same "sacred" biblical allegory: Moses (instead of the angel), the shepherd's staff and the flock of people (here stylized as heads which are thrown about in the picture's centripetality).

But beyond these intertextual connections – *to* biblical mythology – including a direct reference to Revelation in the angel picture (which I shall return to), *to* quotes from Goethe, *to* the poets of the period (Ruskin, Wordsworth), *to* influential quotes from the painters of the period (Claude Lorrain, among others) *in Turner's pictorial oeuvre as a whole,* – *it is* the special thinking in elements, however, which is of particular interest for the present work, and I will not go into detail with neither the biblical mythology nor the historical references.

What Turner actually depicts isn't so much a conceptual connectedness with other paintings, poets, biblical mythology, or history. Perhaps it is rather the elements as forms, and with it the elements as morphologies: that which at once both operates in the foreground of the pictures – the many seas, sunsets, etc. – but simultaneously is far back in the painting, because it is a question of aestheticizing the elements so they become the material the pictorial meaning is made of. David Loshak writes what is plain about the early Turner (until 1810):

What he depicts is properly the drama of the elements in a more puissant way, and based more directly on the observation of nature than had ever been done before, and this applies above all to the sea. Man is

nearly always represented, either actively participating in struggling with nature or simply as a suitable accompaniment.[91]

And about the late Turner (after 1810):

The important thing about Claude's influence on Turner wasn't so much that Turner was now and then inspired to imitate the classical landcape's compositional forms, but that his attention was now concentrated on the *light itself* which from then on was to become Turner's absorbing interest. Turner was especially interested in the light which is seen in the distance and in the sky itself, illuminated by warm rays from a rising or descending sun.[92]

"The Angel standing in the Sun" is, in fact, a picture "made" of light, but at the same time it is fluid with dramatic turbulence, just as it unites light and dramatic flowing rhythm in fire's complex alliance.

One could say that the turbulent centripetal rhythm belongs to the picture's hydrology; the light belongs to the metaphysical "interior" which is distant, however, and the picture's allusion to fire, its pyrology, because of this flowing, watery and shining, airy tendency belongs to the union of these two form-aesthetic phenomenologies. That is my thesis concerning this picture.

And as a first argument for this I will analyse the picture's topology and the imaginary semantics belonging to it. This gives the following in the A universe:

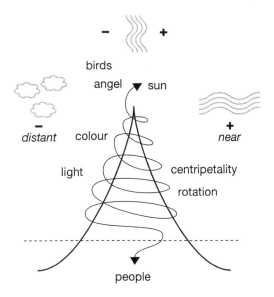

91. Loshak, 1976, p. 9.

92. Ibid., p. 9-10.

And the A – as is typical, incidentally – introduces a natural distinction between angel and people, between that which is "in and up" in the picture and that which is "down and out" of it.

This distinction corresponds, consequently, to the imaginary semantics' overriding projections on the bio-imaginary. The angel will belong to an alliance between the phantasmatic and the bio-imaginary – in such a way that there arises with this angel a union with the human body (bio) and the phantasmatic and divine, now avenging, now redeeming angel. And the people in the picture will constitute an alliance between representing society (the socio-imaginarity) and being also concrete individuals (bio-imaginary bodies) in this society.

The following quote from the Revelation of Saint John the Divine belongs to "The Angel standing in the Sun":

And I saw an angel standing in the sun; and he cried with a loud voice, saying to all the fowls that fly in the midst of heaven, come and gather yourselves together unto the supper of the great God; that ye may eat the flesh of kings, and the flesh of captains, and the flesh of mighty men, and the flesh of horses and of them that sit on them, and the flesh of all men, both free and bond, both small and great.[93]

Without going into exhaustive detail with this theological-mythological framework, it is remarkable simply to ascertain the excited and vertical framework this takes place in: it is a question of the phantasmatic angel placed on the sun (the element connected with light), who is saying something to the fowls (bio-bodies associated with air), in relation to the bodies – the socio-imaginary bio-bodies which are located down in the picture's horizontal plane; likewise the latter are being spoken to there where they belong: down on the ground. And one could add that the passage in itself points out the separation between an upper excited zone and a lower ambivalent zone: it is thus typical that the upper is connected with a dramatic, deterministic content of elements and phantasmatics plus bio-imaginarity, compared to the lower horizontal's content of bio-imaginary flesh and a socio-imaginary society of hierarchies.

The sequence in this A is descending and ascending. Why so? – My thesis is that there is question of an in principle endless and eternal circular movement.

The A with an arrow at both ends corresponds to the situation within catastrophe theory which is called a hysteresis.[94] The picture's formal structure is not vertical. It does not follow a movement from *down* towards *up*, but rather a movement from *out* towards *in*. And the foreground is made up of the circle's outermost "edges;" here is where we find the people; the background is made up by the angel in the centre. And the picture corresponds to a cone viewed from the bottom and up through the cone's "interior." But what is determining is that a movement from *out* towards *in* goes in a

93. *The Bible* (King James version), Revelation 19. 17-18.

94. In physics what is called a hysteresis is: "a cyclical/metabolic exchange between (...) two positions" (See Stjernfelt, 1992, p. 22).

horizontal plane. There is question of a line in which the movement of looking, to be sure, seeks into the picture, but at the same time is sent out again in virtue of the picture's circular turbulence. What is interesting is that it is the angel which controls the centripetality in the picture; *perhaps* some metaphysics and mysticism are based on a centripetal (or corresponding centrifugal) dynamic figure in a cognitive space, in which exactly the limits for *up* and *down* and *in* and *out,* for example, are abolished, and so being are upheld as "eternally" dynamic in virtue of a geometry which is not fixed[95]; and conversely: the picture's rotating form controls the gaze's inward and outward movement. The situation is that of hysteresis.

And the picture's morphologies observe this "eternal" rotation; the light aspect is comprised of the picture's distant dramatic excitation, and the water aspect is comprised of the picture's near formal structure. The close euphoric will correspond to the picture's tactile "watery" turbulence; the distant euphoric will correspond to the light's almost dazzling materialization in the punishing angel who, so to speak, "comes avengingly from out of the distant light."

I invest the sun on the complex vertex for two reasons. In the first place the sun, as a variation on the element air, belongs to a complex union of water and air. The sun is fire, and fire has flame's undulating dense form and light's diffuse character in it. In the second place one could say that Turner paints an extra background having an intuition of the sun. The sun is not explicitly present in the picture, it is hinted through the turbulent flaming sea which emanates from the pictorial centre and runs around in the pictorial space.

This gives the picture a no trifling macrophysical and semantic point; the light can't be painted, just as one cannot look directly at the sun, and above all: one can or must not look at the divinity. It seems as if this picture were a special homage to a configuration of morphology and theology.

And in conclusion, one notes that it is the elements which impel this configuration forth so it becomes an aesthetically consummate form: an angel who is speaking on behalf of God. The God who cannot be portrayed but is represented by the light (an angel) and the form: water's turbulence in the manifested – a painting.

95. The thesis is that some perhaps more delirious and ecstatic metaphysics, such as mysticism's or magic's (Ewald, Eckehardt, Plotinus, Blake), abolish the limits in space, for example through veiling the closed linguistic classes' determining of the space's size, placement, etc.

4. The Water Bringer

I have obtained the poem "XII" from the collection *Förvandlingar* (Changes) (1985) by the Swedish poet Arne Johnsson. The poem is one in the suite *"Anteckningar (Notes) IX – XXI."*

This brings us to the subject of a recent and highly praised Swedish authorship which so far consists of six titles.[96] Arne Johnsson writes elegaic and descriptive verse – often in a syntax marked by an epigrammatic and visual telegraphic style.

The verse is thematically very simple, and it has a clear narrative plane; thus there runs through *Metamorphoses* the story of a love relationship's failure, alongside narrative flashes of childhood recollection. This external narrative "material" is accompanied by a description of nature, place and season which for this reader places the verse in what is practically a dramatic tradition: something is happening right here, in this place, in this nature and at this time of year.

This nature, place and season plane functions as a structural stage direction for the narrative in the poems, and exactly this "dramaturgy" has the effect that the narrative, so to speak, vanishes or rather "turns up" as what becomes narrative points in among the dramaturgical (properly, one could add that this poetry also has connections to the Norwegian and the Danish point novel, as it is seen in Paal-Helge Haugen or with Christina Hesselholdt).[97]

Naturally I favour the description of nature in Johnsson, as does the Swedish scholar Lars Elleström:

Nature was a sign of something mysterious and intangible, as distinct from the nature of adults which primarily is lacking in any extra significance. In Johnsson's poems of childhood nature and the world are contemplated through the elapsed years' membrane of distance, and the world thereby becomes alienated; it is seen anew, but through a filter which, so to speak, mutes and renders the sensory impression clear at the same time -...[98]

But what exactly does it mean that nature is a membrane of distance? Which elements attract a fundamental approach of that kind, and what phantasmatics is this based on?

96. Arne Johnsson's recommendable poetry consists of the following collections: *Förvandlingar* (Changes)(1985), *Himmelsfärd* (Ascension) (1986) - titles which are also to be found in the volume *Ett Paradis, trängt* (A Paradise, Pressed)(1989), which is the third title in this triptych of separate works. In 1992 he published *Dess ande kysst* (Its spirit kissed); in 1994 *Fåglarnas eldhuvuden* (The fireheads of the birds), and in 1995 *Storm av samtidighet* (Tempest of synchronism). Arne Johnsson Received the journal *Lyrikvännen*'s Stig Carlsson Prize 1989.

97. The author Christina Hesselholdt is the Danish translator of *Anne* by Paal-Helge Haugen. The work is a fusion of poetry and novel in what is called a point novel, a genre which is possibly making its reappearance in the fiction of new and younger writers. However, of importance for the present paper is the suggestion that this type of novel is based on the premises of modernist drama (the followers of Beckett): the scenic, filmic and dramaturgic exploitation of the surrounding space (for example, the significance of the space in *Endgame* by Samuel Beckett). This topologizing is also traceable in Hesselholdt's two novels (Hesselholdt, 1991 and 1993).

98. Elleström, 1988, p. 98.

In a way, the selected poem is exceedingly banal with its tale of love and child-hood. One must ask: what is it that makes it a good poem? The thesis would be that the form works on the elements' and the morphologies' scrupulous and taut rhythm and infrastructure; the infrastructure which above (in the quote) is indicated with the (vague) expression: a membrane.

I will analyse the poem.

"XII" consists of 19 lines, which run in a meticulously deliberate disposition down across the page – Johnsson is a figure poet; and precisely the figurative disposi-tion of the lines substantiates the thesis of the significant dramaturgical and structural weft in the poems.

The poem can be divided into three sections: 1) from line 1 to 7, 2) from line 8 to 15, and 3) from line 15 to 19.

The poem relates two things: it gives a snatch of a lovers' scene and a snatch of an experienced childhood recollection. It is possible and worthwhile to describe the poem's sequence in a projection of the stylized time G (cf. p. 59), where one could say that a socio-imaginary reality constitutes a present, a bio-imaginary experience consti-tutes a past, and the phantasmatic-imaginary is comprised of a future.

The poem's present – socio-imaginary – is indicated by the statements: "Februa-ry. It's..." (line 1) and "But it's..." (line 8). These snatches of verse lines indicate transi-tions in the poem; the copula – to be – is used to point with from a "something" over to "something else," just as one observes the insertion of the time horizon: this poem takes place in a month, February, which is a sensory space.

What is pointed to, among other things, is an experienced past which has to do with the child's bio-imaginary semantics: "I become/a child." (lines 2-3), whereupon one slides over into a snatch of experienced knowledge.

But what is also pointed to is the phantasmatic, the plane in the text which – as can be seen in the A to come – determines the text's "dreamlike" narrative plane: "the water bringer."

This water bringer is a reference to the eleventh sign of the Zodiac, Aquarius. In Swedish the sign is called "Vattenhämteren," the Water Bringer, whereas in English it is called "the Water Carrier." And this water bringer becomes the text's phantasmatic fu-ture plane and "all-time" plane – in so far as the latter is in command of that which is to happen and that which has happened.

I will stylize the text's sequence in this manner:

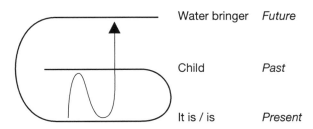

It is noted that the sequence follows the section division. What is special about this sequence – and with it for the poem as such – is the movement it performs within the socio-imaginary area. The poem is meticulously constructed – as is typical with Johnsson – on a deictic pointing reality framework. In this way the poem is like a painting's accentuation of the frame's significance.

This means also that the poem is excited two times. The first time within the child's world ("I become / a child"), and the second time within the adult's world:

But it's/like when I later, in a small white room, /try to coordinate my beloved's yell that I'm to...(lines 8-10).

The poem, in that way, is a poem about the I's two different worlds – but underlyingly held together by the socio-imaginary I which looks back in recollection and ahead in ideation. The interesting thing is that this is held together in a plane precisely in such a way that the poem obtains a coherence. This coherence is analogous to the aesthetic material's uniform character in the first and second excitation: namely the elements and the morphologies. In both intersections of the excitation threshold it is the light and the water which act in the recollecting and visualizing overall frame-subject, which naturally is bio-imaginary; the bio-imaginarity and the consequent phantasmatics are structured, in the cogent sense, layer upon layer in this poem. First you have the frame, reality, which is then recollected – on the aesthetics and material of the elements.

I will project the poem in the A:

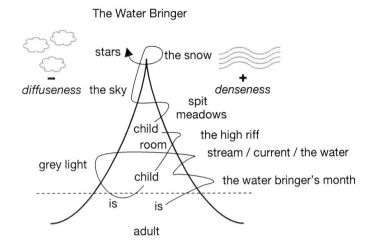

The Water Bringer

I invest the poem between its forms of denseness and its forms of diffuseness – naturally one also notes the thymic morphologies in that connection.

After the first stage direction the poem is sent out into the water's material, indicated by the genitive "the water bringer's month" (line 1).

Immediately it must be asked: why don't I place the water bringer's...on the complex apex, where, after all, I place "The water bringer"?

I do not, as it happens to be a question of the possessive case and so it is not indicated, in that sense, as being other than an addendum to the month.

This genitive, meanwhile, is important for the problem in the text – which at the same time is one of the reasons why I have chosen the poem for inclusion in this paper: The poem's water aspect is plainly not based on a simple euphoric morphology. In other words, could it be a matter of a disillusioned water aesthetics? We notice formulations like:

the water gleams like dark metal/in the grey light, a thin/vibrating membrane (lines 5-7).

The dysphoric, then, if not indicated, is close to being the boy's experience, however, and as we see: operative in the hydrological element.

The answer, meanwhile, is that the genitive draws the dysphoric "reality" along into the excitation area – just as the whole poem acts ahead towards the phantasmatic "Water bringer," which determines the situation. There is in the use of "The water bringer," as I will assert, question of defining an ideation which in a complex alliance controls *intentionality and causality*.

The poem moves from the state of water – as I demonstrate – subsequently over into a "pure" dysphoric state with the "grey/light." The water's euphoria is indeed

faintly indicated, but compared to the light's morphology with this catastrophe surface it is a question of simple dysphoria. The poem is thereupon sent down under the excitation limit indicated by the copula.

The poem signals by this means a transition to a new event space: description of the lovers' scene: "that I'm to leave" (line 10).

And the poem's adult I leaves: "with the high and a riff of Charlie Parker" (line 11).

That the I leaves with the intoxication and a few bars of music is, then, the poem's pathos projected on the water's euphoria and causal forces. It is said exactly of these natural forces:

I/spit in the water, the white dot disappears in/under the ice. The sky darkens... (lines 13-15).

Something is carried away: the I's "love" projected on the elements' macrophysical causality.

And this connection between recollection's socio-imaginary – and intentional point of departure – (that there is a subject which simply is directed towards something: childhood and the ideation), and the pure forces of the causality are given free play in the concluding lines:

The sky darkens,/the water bringer/lowers his amphora, fills it/and empties over the world. The snow falls, it looks like stars (lines 15-19).

In this tour de force of a poetic conclusion, simple and tautly rhythmic, the poem oscillates in the following manner:

From the light's threatening dysphoria ("The sky darkens") over into the ideation's complex phantasmatics with "The water bringer." A figure which viewed dynamically must be an alliance figure, partly hermeneutic (the Zodiac and its associated astrological mythology), partly dynamic.

Notice the intuition the poet builds on. The phantasmatics both fills and empties, and what it fills and empties is the elements' material: "The snow falls, it looks like stars" (line 19). What is spoken of here is a "both...and," one might say. The phantasmatics is built on this element material, the dynamics and the interpretation appear to say.

Finally, something is built on the complex alliance in the poem: the recollection's directedness seen from "reality" – the intentionality – "But it's / like when I..." – and the causality: the light and the water.

It gives good meaning to assert that the elements' material and imaginary morphologies are based on such built-in *backgrounds. And the aesthetic, rhythm and the manner of representing the material is based on such materials if it isn't these materials.*

5. Heavenly Solitude

In 1944 Edward Hopper (1882-1967) paints a road which leads past a house at the edge of a woods; this asphalt road curves to the right out of the field of vision, a horizon line runs through the picture from the picture's left edge to the right. The horizon line marks the transition to an overcast sky.

Hopper calls this picture *Solitude*. Like the other mature pictures of Hopper's, *Solitude* is a puristic work with few realistic objects: the road, the house, the horizon, the sky, the grass and the trees. And *Solitude* bears the distinctive mark of this painter: a crushing monotony, a dreary, distressing emptiness with a fundamental lack of communication.

The absence of communication has to do with the tedious lack of events in the pictures – that in spite of the realism which Hopper appears to paint in. The special artistic touch Hopper is master of is that the reality and realism emotionally refers to events and to phantasms which are then disappointed in their expectations, and instead one is confronted with absence and a theme of modern isolation in an American postwar urban and landscape picture; exactly in a situation where America is characterized by the euphoric mood at having won the Second World War. What Hopper paints is not the extrovert optimism, but an introvert desolation: like the street in *Early Sunday Morning*, the interior in *Sun in an Empty Room*, the daydreaming usherette in *New York Movie* or the famous picture *Nighthawks*, or as here *Solitude* and:

When one interviewer commented on the lack of communication in his paintings and on the "profound loneliness," Hopper replied: "It's probably a reflection of my own, if I may say, loneliness. I don't know. It could be the whole human condition.[99]

However, the special challenge in Hopper's painting is not this thematic or hermeneutic-historic horizon – for one reason: it is to an exceptional degree true of Hopper's painting that this thematic is distinct, cogent and "much too simple", namely, the story in modernity's accentuation of "the loner, the isolated person and the alienated individual." Hopper's pictures are a powerful underscoring of modernity's narrative of the stranger. Safe to say it is obvious with this aesthetics.

And in that way Hopper is a particular challenge for this interpretational praxis. How does this realism function aesthetically, semantically and cognitively in a dynamic reading?

In the first place the picture is a problem semantically because there is almost no semantics to describe.

99. Hopper, 1984, p. 69.

This means, in the second place, that the picture's cognitive framework is reinforced. This will be my thesis about this picture.

And in the third place, this means that *Solitude* "plays" on a conflict between the open semantics and the closed cognition.

A first step would be a description of the gaze's path through the pictorial space.

What strikes the gaze is 1) the road 2) the sky formation 3) the house at the edge of the woods and 4) the grass. This "looking path" can be stylized thus:

That there is very probably question of a looking path which is forced into field 1 (the road), then field 2 (the sky), then field 3 (the house at the edge of the woods), and then field 4 (the grass), can be corroborated by a simple test: it is hard to visualize that the gaze will first investigate field 4, then 3 and so forth. It can only be done with difficulty. It isn't natural. Why not?

One can answer that the gaze observes a description framework which is forced into a conceptual framework, that which in language corresponds to the closed word classes.[100] The gaze moves from "down" in the direction of "up" or from "in" in the direction of "out"; this "up" and "out" in the sphere of the elements: the air, the sky, and this "down" and "in" are the road. In other words the gaze follows a vertical reconnoitering movement in the conceptual background. Finally the gaze follows in advance of this a fundamental path in across the edge of the pictorial frame at the bottom of the picture, and subsequently out the pictorial frame's upper edge. The gaze is confronted in this overriding sense with the fixed uniformity in the road at the bottom of the picture and the soft – but mixed – uniformity in the spherical perspective: the air, the sky.

But the picture also observes a fundamental morphological paradigm: it is the

100: See Talmy, 1992 (and 1988). The open word classes are verbs, adjectives, and the closed word classes are prepositions, conjunctions and participles. What manifests itself in Talmy's work is an investigation of these classes' forms in the exercise of language. And it might be added that conceptual structure is closed and semantic structure is open. This means that closed conceptual structure can be constituted as closed in virtue of the word classes' deterministic and controlling form. And semantic structure is generated on the basis of this closed material.

"near" versus the "distant." And here the road and the sky are determining for the constituting of this paradigm.

The road in the picture marks the transition from the picture's lower edge, obliquely curving up to a new edge, the horizon line, whereupon the gaze is led into the element world.

The gaze is led by a path which, so to speak, lies at one's feet. This "near" area can be identified with the notion of a body which is simply walking on the road. In contrast to this the sky axis contains no notions proper of a body in movement – the light, the clouds and the greyness play on an identification with something closed, unresponsive and therefore also "elementarily" menacing. The gaze is confronted with an excited objectivity of absence (and death). But first and foremost a closed, spherical distance.

I will topologize the picture in this way:

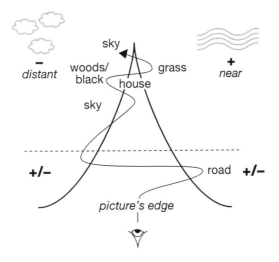

The gaze is led in across the institutional aesthetic and quasi-socio-imaginary frame – the picture edge; dynamically this corresponds to the gaze being led from a local non-focus to a focusing in an ambivalent conflict space: on one hand, the road in question belongs to a euphoric identification with a body which is walking there, but on the other hand the body finds itself in a piece of reality, on a road, which is deserted – a socio-imaginary "horror vacui." The bio-imaginarity and socio-imaginarity are, in this zone below the threshold, in an ambivalence: between reality and possible subjects in this reality.

From there the gaze is led up over the threshold – in yet another orientationless space: the sky. In the concrete sense this state change is indicated also by the horizon

line. Possibly the horizon in the macrophysics is just such a general state change: between that which we know something about, reality and the events in the world, and then the closed heavens about which we can only daydream phantasize, more or less extatically.

This sky space is a distance space, dysphoric and morphologically remote. But it is an excitation space, in so far as there is question of an ideation space, a phantasmatic space, in an alliance with the bio-imaginarity in the way that it "plays" on the subject and the body as absent and deathly.

Subsequently, the perspective is shifted into an investigation of the house at the edge of the wood. And accentuated here is the alliance between the ideation space – the phantasmatics – and the identification with the body – the bio-imaginarity; the gaze will instinctively investigate the house: is there somebody walking around in the house, is anybody there? What is going on?

The house is located in the excitation's ambivalence space, between the legs of the wedge. For the reason that thymically it is neither entirely euphoric or dysphoric, or near or distant. It isn't possible to determine what is taking place in this space. The house indicates both bio-imaginary protection, but also "horror" as the ideational universe, so to speak, becomes transparent, it can imagine itself as being inside the house (bio-imaginary security) or it can be shut out; the phantasmatics, so to speak, can't come in, the values about the house will be nervous and ambivalent: excited.

From here the gaze is sent into still another distance and remoteness morphology: the edge of the woods in the background. The black branches of the pines confront the gaze with the invisible: what is in back of the trees? The gaze becomes confronted with a refusing and "dangerous" space (bio), which again is in an alliance with the phantasmatics: what is taking place there among the trees, what is on the other side?

This is also put in relief by the grass's ripe yellow euphoric nearness. The grass is in substance akin to water (waves of grass in the wind), just as fire and light can be suggested in connection with this grass. The grass is this picture's only pure euphoric value.

And concludingly this nearness perspective is again refused by the sky formation, the space which determines the whole picture in virtue of its "pulling" at the gaze. The gaze ends up there every time, in virtue of the road which forces the sky out into focus.

The picture's "speaking in elements" becomes an addendum to and underscoring of the title: "Solitude."

The above imaginary semantic and dynamic interpretation rests – at bottom – on a more frail foundation, however, for the simple reason that we are speaking of a picture. A reading of a picture necessarily always reposes on the beholder's ability, with this or that theory, to register or describe his way through the pictorial space. It is easier with a textual material, because a textual material reposes on direct statements; this means conversely that a painting's few and scattered statements – a title, for instance – acqui-

re exceedingly important significance for the describing of the picture (an uncomfortable retrospective question to the above interpretation would be: what if the picture's title had been "Happiness"? – presumably the answer would have been: it is irony, but nonetheless...?).

I will take the consequence of this and attempt to clarify what can be said about the picture's conceptual "objectivity."

The thesis is that the picture reposes on a conceptual structure, which consists of three backgrounds (cf. Chapter 3): *an event background, a state background and a field background.* These backgrounds are closed schemas in which the description of the picture becomes possible. And with it the semantics.

The event background, which semantically has its counterpart in the verbs, will be the picture's horizontal plane: the road and the house. On the whole that part of the picture which will correspond to a possible action area for the registering and identifying subject. Here in this area – in the picture's horizontal plane – occurs a conceptual area for movements and changes.

The state background, which semantically has its counterpart in the nominals, will be the elements' area, here the sky area. And one would now believe that I am contradicting myself, for both the road and the house correspond to nominals and therefore cannot be found in the state area. Meanwhile, it is my thesis that precisely here is where "it's happening," *for the sky's "cognitive state" of closedness, mere state, operates down on the picture's horizontal plane, in such a way that the horizontal plane is conceptualized to become pure states: the road and the house are, in a way, element worlds.* And this conceptualizing of the event world from the state world is this picture's proper aesthetics and formal mastery. Possibly it is even what makes this picture more abstract than realistic.

Finally, the picture's field logic, which has its counterpart in the adjectives and adverbs, would be the picture's various potential transitions, the fields that determine where one is in the perspective: is one on the road or up in the sky? These fields, in a conceptual background, will involve various compelling circumstances: one can stand on the road but not on the sky, one can be drawn into the picture and in over the picture edge, but not down in the sky or back in the gaze. And the fields will also affect the potential mood which the picture affects; it will undeniably be hard to feel "happy" in this scenario; to that the event background answers: nothing is going on, and the state background answers: *that it is a pure nominal state of mere trees, house, road and sky – so that the adjectives' feelings must answer that the landscape is lonely.*

In resumé it means that the above closed conceptual background – closed because this cannot be communicated but merely is present as a background – is an abstract framework which, meanwhile, operates in the dynamic and imaginary semantics – for instance, in the dynamic interpretation of the different topoi in the painting and their placement in the morphological catastrophe surfaces. As far as I can see, the conceptual background bears out the imaginary semantics and morphology.

And the open dynamic reading – open because it is lexically and semantically heterogeneous with the three imaginary strata – becomes a reading which takes place at a higher level in virtue of the three strata, but which, nevertheless, is based on the conceptual background.

In conclusion it means that precisely this picture and this aesthetics find their point of tension between what is semantically readable – with the little information that is given – and the conceptual background.

The picture's "speaking in elements" becomes an aesthetic form which makes it possible: the air and the sky cognitize and semanticize the picture. *The elements' aesthetic material is located someplace between these levels in the interpretation.*

6. The Light in the Desert

The poem "Inspiration," from the Danish poet Simon Grotrian's collection *Livsfælder* (Life Traps), with its title suggests that what it deals with is writing as genesis; the poem in that way becomes a party to a writing-oriented modernist movement, where it has its local take-off in the so-called eighties generation whose pioneers include Danish writers like Søren Ulrik Thomsen, Michael Strunge and Niels Frank.

Grotrian's authorship deviates from Thomsen's symbolism, Strunge's and Frank's wild existentiality inspired minimalism by cultivating, with and following the collection *Kollage* (Collage) (1988), the neo-Surrealism of a chamber of horrors – a surrealism which in the present poem can be compared with a Francis Bacon.

However, the poem as a writing-modernist work is not a submission to a concretistic investigation of materials (like the early Peter Laugesen, for instance), but rather it appears to stage its own literary genesis through the external: partly through the topology and partly through the elements. Between them a third instance is found: it is the poem's subject.

The topos of the poem is the desert, which functions as an undelimited whole – practically as a canvas on which the poet's imaginary strata and textual inventory are, so to speak, imprinted:

...the ink flows/through the sand, I try to save myself/but hit the dromedaries/squelching with black footprints beneath my eyes. (lines 7-10).

And further, the poem's inventory can – with the poet's words – be described as a caravan movement through the sand:

the caravan paces the sky/and the sun warms roofs (lines 23 -24).

Precisely this caravan movement seems to be a valid statement of the poem's content of surrealistic contortions – the caravan is long, it winds like surrealism's phantasmatic contortions and inversions of perspective and reality:

necklaces of bedouins dance on my desk (...) a knot of snakes writhes with tails out their maws. (lines 4 and 20).

The poem's 26 lines can be divided into three spaces; the first runs from lines 1 to 6, the second from lines 7 to 24, and the third is comprised of the two last lines in the poem – 25 and 26.

The first and second parts describe a bio-imaginary space and a phantasmatic space in combination, mainly in such a way that the first part describes the body and the place:

where deserts grow/vaster than my mouth (...) pupils of onyx which see nothing (lines 2-3 and 5-6).

The second part amplifies the description of the place parallel with the ideation's terri-fied phantasmatics – decisively expressed with the line: "I try to save myself" (line 8). The third part rounds off the poem – in so far as it leaves the bio-imaginarity (the body) and the phantasmatics. Remaining is what will apply as a socio-imaginary ascertainment:

There are bright days, now and then/the dark is there, first and last (linie 25-26).

The poem's sequence in this way becomes a processual purification process; the poem "deal with" leaving the bio-body and the phantasmatics. The poem's subject dreams of becoming "pure like a desert." This is supported by the departing lines: the adjectival bright and the substantival dark as colour domains belong exactly to a lack. The brightness is not cogent, and the dark belongs in the Merleau-Pontian sense to the invisible.

This purification process of the poem's can be invested in the stylized G thus:

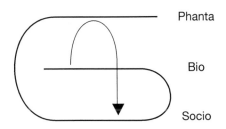

The G shows a warning sequence, where the warning of the impending consists in the purification thematics: if the poem's subject is saved he remains behind – bright between the temporal sequence of days and dark. Finally, the G makes graphic the movement from a body space and a phantasmatic space to a socio-imaginary reality space.

Meanwhile, the G doesn't show the sequence's internal conflicts. And here these conflicts can, in an eminent degree, take their point of departure in the elements and morphologies. The thesis is that the poem plays out a conflict between the dense water and the distant, diffuse light.

The light aspect (star shadows, night, shadow, sky and the sun) can be thought of as a morphological substratum which contains (and controls) the entire desert paradigm (deserts, bedouins, the sand, dromedaries, cactus, (oasis) and the caravan). There is question of a mostly dysphoric landscape of diffuseness and comfortlessness.

The water aspect in the poem is not so extensive as the light aspect, whereas it does contain the poem's few euphoric – but faintly marked – densenesses. The poem speaks of an oasis and of the ink as the most important hydrological principles. The pivotal place for the hydrological is the oasis, an oasis which functions as a delimited and peaceful point in the desert's horror-vacui. The oasis can be regarded as a chorem which offers a denseness, a delimited whole set up against the light's distant diffusenesses.

The poem contains, in addition, a complex fusion figure in the sun (which unites the hovering and undulating), where the sun in this poem constitutes an alliance figure which unites the poem's oscillating conflict between light and water.

I will describe the following universe:

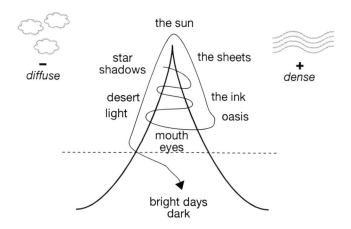

This oscillating conflict is a conflict of state between the light's forms and the water's forms.

Even the poem's first line: "Star shadows whirl across the sheets" is, in a way, exemplary for describing this conflict. The stars (light) and the sheets (paper – in Danish *ark*, especially also as reference to the biblical ship: *Noah's ark*) belong to the indefinite discontinual as opposed to the continual. The stars and the shadows are a discontinual undelimited quantity (notice also the indefinite plural) which whirls across the sheets (definite plural). In other words, there is question of the undelimited as opposed to the delimited. And one could add, in Talmian terms, that the star shadows are antagonistic – in so far as they as forms – are menacing (element) principles in virtue of the discontinual whirling. This discontinual menace is conveyed in virtue of the verb: to whirl; a movement which can be imagined as destroying the sheet's continual form and surface.

From this point the conflict oscillates accordingly down through the poem – between light/desert and ink/oasis until the conflict is united with the sun, which sends the poem up in a complex point and further down into the impersonal socio-imaginary reality.

The poem's body parts (the mouth and the eyes) are placed between the legs of the wedge and above the excitation boundary – as subjectal references.

And the alliance between the bio-imaginarity and the phantasmatic consists in their contortions across the elements' forms and morphologies. Cogently expressed in this example:

And my own shadow breaks/like a cactus between the tents (lines 11-12).

The shadow and the cactus belong to the contorted – the bio-imaginary and phantasmatic, contorted subject. And the surreal and phantasmatic aesthetics – in this case – attracts the surreal desert and light-landscape forms because these forms are designations pure and simple for the divided and morselled subject.

The bio-imaginary and phantasmatic alliance appears to be a sacrifice by the forms, staged on the light surface:

deserts grow/vaster than my mouth (lines 2-3).

The topos is larger than the body, and the landscape becomes an example of a surreal sacrificial practice by bio-imaginary and phantasmatic material ahead to the impersonal picture of reality in the poem's last lines. The poem speaks outright of an evaporation, and the latter marks the poem's state and phase transition:

I rest a little in oasis/as the humps evaporate/the caravan paces the sky/and the sun warms roofs (lines 21-24).

The subject is assigned an ideation of a rest in the euphoric water aspect. The oasis is moreover interesting as the phantasmatic's notion of the possible place for a mirage. A mirage which is intuitively carried further in precisely the evaporation, – where the ideational universe configures with the water's form (the water evaporates). And what the poem evaporates is the poem's inventory, its humps and conflicts.

This is where we arrive at the sun, which warms roofs. The sun becomes the poem's point of fusion proper. And it is in virtue of the union of the poem's element conflict. What is interesting, subsequently, is that this can be imagined also as being a phase transition – and disarming – of the poem's imaginary problematics, in other words that the alliance between the phantasmatics and the body is abandoned because it *can* be made invisible in the complexity's reference to both bio-imaginarity and phantasmatic-imaginarity, the one thing and the other.

Remaining are the statements:

There are bright days, now and then/the dark is there, first and last (lines 25-26).

And besides being – as mentioned above – an example of an impersonal ascertainment of reality, it is interesting to observe the built-in ambivalence which is implied in the statements. One could ask: when there are bright days "now and then" and dark "first and last" what, then, is being spoken of now and then and first and last?

To which the answer must be that it could be the poem's own self-commentary to partly the element conflict (light and water), partly the time which is squeezed in this conflict as a dark: the dark which the dysphoric alliance between bio-imaginarity and socio-imaginarity comprises in this impersonal and ambivalent area.

From this there arises a possible interpretive element analysis, in which the poem's surreal and "psychic" contortions observe what is the elements' aesthetics: an oscillating conflict "between morphological" backgrounds.

These backgrounds make it possible to observe some form-specific forces which are probably communicated in the aesthetic surface, but also especially are merely present as the aesthetic basis itself.

And this poem speaks *about these aesthetic conflicts – in order parallel with this to be able to speak about the subject's contortions and possible states.*

7. THE AESTHETICS OF THE ELEMENTS: CONCLUSION

The specifically aesthetic in a work of art – as is well-known – concerns the way in which the work of art appears as form and as meaning. This means that the aesthetic itself becomes in practice a hybrid quantity; there is not only one aesthetics there are many, each of which claims to be the correct or the proper and "true" aesthetics. Meanwhile, it is this paper's conclusion that the aesthetic, and *the form* and the meaning as such, are established on some general immanent regularities. *They are the elements and the morphologies.*

The goal of the analyses has been to demonstrate this, and the six analyses each comprise diverse aesthetic horizons; but in this diversity there is in every case question of generating form and meaning through the materials and morphologies of the elements.

As far as the analysis of "the Nook of the Eight Paths" is concerned, we see philosophical thought and aesthetics drawing on an "existential" experience of nature, in such a way that the specifically philosophical, precisely in its processual thinking, *thinks with* the elements and the morphological background. The experience of the beautiful and erotic becomes for Kierkegaard an experience which must assume different ecstatic climaxes, just as this analysis shows a fundamental conflict between the individual and the collective. The collective, society as such, cannot think; the individual can, but only in virtue of the emotions' projection on the aesthetics and morphological background of the elements. This existential "scope" is based on an establishment of a topos, here the nook but more generally: the individual. Kierkegaard's nature ecstacy is more than merely inherited from a romantic intertextuality, and it is more than merely a nominalistic strategem, as Arild Christensen asserts. The nature ecstacy and the dynamics in it constitute the phenomenology of the thinking itself. Michel Serres' phenomenology, which in *Les Cinq Sens* seeks to "de-invest" the rational analytical philosophical language, formulates in a way what was unclear for Kierkegaard: that thought and cognition are based on the aesthetic's forms. True, the Bonnard analyses are a result in a work, but especially also a result in the condition for being philosophy, or rather for becoming philosophy. And "the Nook of the Eight Paths" is likewise probably a contribution within a contribution to a philosophical work, but as observation of nature it is founded on some general conditions for the cognition of the beautiful. Cognition as such is probably a judgement about "something", but it is a judgement which reposes on something: the aesthetic.

And conversely, while it is far, in a diachronic sectional view, between Kierkegaard and *Bjørnvig's nature aesthetics*, it is striking to see the same thinking with the elements and the morphologies as backgrounds for the attainment of the ecstatic and,

here, the individual. In the same way as Kierkegaard, "The Dune Mirror"'s thinking shows a number of interchanges between morphologies and elements. And what is important: the establishment of the specifically individualistic – the basic elements – comes about in a conflict with the collective.

"The Dune Mirror" differs from "the Nook of the Eight Paths" in that there is here question of a greater degree of emotional fluctuation. Even the chaotic dynamics (of baseless horror, of inexplicable rejoicing) are impassioned states which are generated going from the morphological thymics. And the elements are the material which, in the final instance, becomes the immanent aesthetics itself from which the metaphor (the Dune Mirror) is formed. Along the way I have only given sporadic mention to the metaphor's role, but it is plain that one aim of this paper is to argue for a depth level from which the metaphor can be imagined as arising. Furthermore, I attempt in this analysis to read Bjørnvig at the words, in such a way that each word refers to such and such an imaginary semantics. This gives a hyperliteral interpretation strategy – invested as it is in the imaginarity theory.

With Turner there is question of an almost impressionistic aesthetics. Turner's aesthetics – by his contemporaries and a large part of posterity (most recently Northrop Frye) called a "vulgar" aesthetics – is founded on the "play" itself between a watery, flowing and centripetal formal rhythm and the light's (the angel's) metaphysics. Here it is also the aim to show this collision of the form's tactility and processual development and thought's and metaphysics' more distant (abstraction) and "airy" morphological basis.

With Johnsson and Hopper, as far as both are concerned there is question of what could be called a realistic aesthetics. In Johnsson's case this realism is a deictic realism, which exploits the ability to go from a reality space – with thoroughly written specifications as to whence there is being spoken – further out and back in various other experience spheres. A possible Johnsson study would conceivably give this further treatment. As a point in passing, it also applies that the present work's "hard" semiotics can now reason more closely as to what the vague expressions, such as Elleström's membrane, for example (cf. p. 80), actually are. Here I naturally show that the membrane can be the elements pure and simple. And the reality space – the socio-imaginarity – is (as a possible thesis) based on intentionality, as opposed to which the elements (and possibly the morphologies) are based on causality. It is here a possible connection between the natural world and the imaginarity's semantics takes place.

With Edward Hopper there is also – as mentioned – question of a realism, but unlike the Johnssonian realism, which, after all, is verse with many potentials for imaginary semantics, there is with Hopper question of a realism which is, so to speak, devoid of semantics. Therefore, I endeavour to reason for a conflict between the cognitive framework and the imaginary semantics, and the elements are naturally present in both areas. A necessarily prospective Hopper study could be envisioned as working with this connection.

With Simon Grotrian, as compared with the other analyses, there is question of something entirely different: namely what could be described as a neo-surrealism. Here there would in another connection (again in an internal study within comparative literature) be a possible further point in examining the connection between a hermeneutic psychoanalytical "symptomatological reading" and a dynamic reading. The elements in this poem are based on a conflict, and this conflict is possibly also analogous to a conflict in the poem's subject.

These six analyses are naturally associated with a historic period, they are diachronic and on the whole connected with an age. Whether "Bjørnvig", "Johnsson", and "Grotrian" survive for the future – the way "Kierkegaard", ("Hopper") and "Turner" obviously do, is beyond this paper's sphere of judgement. But the carrying argument in this work is that the elements and the morphologies are if not *the aesthetic* then a significant content in the aesthetic; this is corroborated by exactly the diachronic differences in the works, which, everything else being equal, show the elements' carrying synchronic expression in the form.

This brings me to a comment on the analytic strategy itself of this work. And for use in this comment I will redepict the A and G the way they can be imagined as being built into each other:

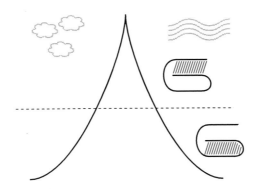

The interpretation strategy is based on a dynamic method and an imaginary semantics. But in the case of both embedded fundamentally in a phenomenology: a third and imaginary phenomenology, at bottom.

Where what the model can do is to show a threshold value, a genotype and a phenotype (cf. chap.5), whence the three imaginary strata, the bio-imaginary, the socio-imaginary and the phantasmatic-imaginary become meaning. The specifically aesthetic will therefore be the space which oscillates in the universe's surfaces themselves. The following depiction can possibly elucidate the aesthetic's primateship:

My point will be that an aesthetic form – if it is to be consummate in the way that it unfolds textually or tactilely – is a movement which in part oscillates between the catastrophe surfaces but especially also seeks a complex vertex, *before it can fall back* in a new ambivalence area. What is important is that the complexity forms an abode for the form's interchanges. Conversely, it means that unsuccessful works of art are unsuccessful precisely in virtue of their lacking ability to become complex – or possibly even to oscillate (what is called rhythm). Intuitively it applies to the discernment that the unsuccessful work is described as "disappointing" (in other words it is incapable of exceeding the threshold value); it is described as rhythmically abortive (it is incapable of oscillating between the catastrophe surfaces); the examples are many, and I will let this remain open.

In the A and the G it applies that the invested semantics repose partly on the thymic morphologies, partly on the form related morphologies. Early on in the work my argument is by way of Brøndal, the Brøndal who seeks universal parts. It ought to have appeared that these universal parts are, in this connection, the elements and the morphologies. But what, then, does this mean?

Two things: in part that these universal parts are components in the imaginary as well as in the cognitive phenomenology. They can be compared with the Merleau-Pontian pre-being, only here they aren't so much units of being but rather emotive values and formal schematics, respectively thymics and forms.

The complex passions (fear, rejoicing, horror, etc.) and the elements are based on these relatively impoverished thymics.

Meanwhile, the elements are based – as mentioned – also on spatial schemas for nearness and for diffuseness – at a higher linguistic level they are modalized into either having or lacking the latter. And one could say that again it is the bio-imaginary which establishes such a perception, in so far as it is here an "aboriginal" form generation and

formal perception of the world and the subject are created. It is simply "better" to have the near good at close quarters in preference to the (distant) comfortless. And these phenomena will be forms, in so far as forms are substantial and schematic units that are made visible and delimited – either continually or discontinually.

Possibly this is a much too concrete manner of developing the interpretation. But the question has to be reversed: it is precisely in this concretistic phenomenology that form, aesthetics and phenomenology find the interpretation strategy of this work. Here, linguist Leonard Talmy's concretism is a prototype for the further work this theory must have ahead.

A final point, – the work is indebted to phenomenology as an area of scientific theory. And this phenomenology was established historically in three stages: a phenomenology founded by Husserl; however, I do not read this philosopher directly but instead employ Merleau-Ponty – these two constitute the first phenomenology. A second phenomenology would be the catastrophe theory developed by René Thom, which makes it possible to form a dynamic interpretation like the above work's. A third phenomenology is, subsequently, an *imaginary-phenomenology* – as is roughed out in this work. This is the necessary perspective which lies in advance.

And as a theoretical work like the above enters into a socio-imaginary semantics – simply being intentionally directed towards the future, the *airily* distant – which reposes in *objects,* thoughts expressed under a title (bio-imaginarity) and *ideas,* a number of semiotic suggestions for new model formations (phantasmatic-imaginarity), a first step towards a phenomenology of the imaginary is concluded, and hereby put forward.

BIBLIOGRAPHY[1]

Bible, The King James version.

Brandt, Per Aage 1991: "Det imaginære" [The Imaginary], *Almen Semiotik nr. 4*, Aarhus: Aarhus University Press.

Brandt, Per Aage 1992: *La Charpente modale du sens* [The Modal Patterns of Meaning], Aarhus, Amsterdam/Philadelphia:, John Benjamins Publishing Company.

Brandt, Per Aage 1983: *Sandheden, sætningen og døden* [The Truth, the Sentence and the Death], Aarhus: Edition Basilisk.

Brandt, Per Aage 1991b: "Bemærkninger om passionen" [Remarks on Passion], *Aktuel Semiotik - Form og objektivitet 1*, Aarhus: Nordic Summer University.

Brandt, Per Aage 1989: "Ild og vand" [Fire and water], *Den brændende fornuft*, Copenhagen: Munksgaard.

Brandt, Per Aage 1995: *Morphologies of Meaning*, Aarhus: Aarhus Universitetsforlag.

Brøndal, Viggo 1991: "Sprog og logik" [Language and logic], *Almen Semiotik* nr. 4, Århus: Aarhus Unversity Press.

Bjørnvig, Thorkild 1972: "Klitspejlet" [The Dune mirror]*Udvalgte digte*, Copenhagen: Gyldendal.

Bundgaard, Peer Franz 1992: *Metafor og billedbevidsthed - udkast til en neutral ontologi* [Metaphor and Image Consciousness], Special Dissertation to Department of Literary History, University of Aarhus.

Christensen, Arild 1964: *Kierkegaard og naturen* [Kierkegaard and Nature], Copenhagen: Graabrødre Torv's Antikvariat.

Elleström, Lars 1988: "Barndomen, Åldrandets myt" [The childhood and the Myth of old age], *Nordica bd.5,* Department of Nordic, University of Odense.

Friedrich, Hugo 1987: "Strukturen i moderne lyrik, København: Gyldendal. Originally printed under the title : *Die Struktur der modernen Lyrik*, Hamburg 1956, Rowohlt Taschenbuch Verlag.

Grotrian, Simon 1988: *Kollage* [Collage], Copenhagen: Borgens Forlag.

Grotrian, Simon 1993: "Inspiration" [Inspiration] *Livsfælder*, Copenhagen: Borgens Forlag.

Greimas, A.J. et J. Courtés 1988: *Semiotik. Sprogteoretisk ordbog,* Aarhus: Aarhus University Press. Originally published with the title *Sémiotique. Dictionnaire raisonné de la théorie du langage*, Paris 1979.

Hansen, Vagn Lundsgaard 1989: *Den geometriske dimension,* [The Dimension of Geometry], Copenhagen: Nyt Nordisk Forlag Arnold Busck.

Haugen, Paal-Helge 1992: *Anne,* [Anne] translated into Danish by Christina Hesselholdt, København: Edition Basilisk.

Hesselholdt, Christina 1991: *Køkkenet, gravkammeret og landskabet,* [The Kitchen, the Burial Chamber and the Landscape], Copenhagen: Rosinante/Munksgaard.

Hesselholdt, Christina 1993: *Det skjulte* [The Hidden], Copenhagen: Rosinante/Munksgaard.

1. A title in brackets [....] - indicates a translation of the foregoing title, not a complete published translation of the work mentioned.

Hopper, Edward 1984: "Solitude", in: Gail Levin, *Edward Hopper,* Bofini press corporation, Naefels, Switzerland.

Hopper, Edward 1944: *Solitude,* Oil on canvas 32" x 50", private collection. *See appendix.*

Jahn, Birgitte 1992: *Landskabsmaleriets semiotik* [The Semiotics of Landscape], Special Dissertation to Department of Romance Studies, University of Aarhus.

Jefferson, Ann (ed.) 1989: *Modern Literary Theory,* London: B.T. Batsford Ltd.

Johnson, Mark 1992: "Philosophical implications of cognitive semantics", in Dirk Geeraerts (ed.),*Cognitive Linguistics, volume 3-4,* Berlin-New York: Mouton de Gruyter.

Johnsson, Arne 1988: "Förvandlingar, Anteckningar dikt XII" [Changes, Notes Poem XII], *Ett Paradis Trängt* dikter 1985-1988, Stockholm/Stehag: Symposion Bokförlag.

Johnsson, Arne 1992: *Dess ande kysst* - dikte, Stockholm/Skåne: Brutus Östlings Bokforlag Symposion.

Johnsson, Arne 1992: "Brev af glas og vand" [Letters of glass and water], translated into Danish by Hans-Erik Larsen, *Banana Split* 2, København: Edition Basilisk.

Kierkegaard, Søren 1988: *Stages on Life's Way,* Edited and Translated by Howard V. Hong and Edna H.Hong, Princeton, New Jersey: Princeton University Press.

Kierkegaard, Søren 1967: *Søren Kierkegaard's journals and papers,* Volume 1, A-E, edited and translated by Howard V. Hong and Edna H. Hong, Bloomington and London: Indiana University Press.

Loshak, David 1976: "Indledning" [Preface], *J.M.W. Turner - akvareller og tegninger,* kobberstiksamlingens udstilling nr.151, Copenhagen: The National Museum of Art.

Lyngsø, Niels 1994: *EN EKSAKT RAPSODI* - om Michel Serres' filosofi [An Exact Rhapsody - about The Philosophy of Michel Serres], Copenhagen: Borgens Forlag.

Mortensen, Dorthe 1991: *En semiotisk tekstteori* - og en læsning af Karen Blixens Drømmerne [A Semiotic Theory of The Text - and a reading of *The Dreamers* by Karen Blixen], Special Dissertation to Department of Communication, University Center of Aalborg.

Mortensen, Klaus P. 1993: *Himmelstormerne* - en linie i dansk naturdigtning [The Titans - a line in Danish Nature Poetry], København: Gyldendal.

Merleau-Ponty, Maurice 1962: *Phenomenology of Perception,* translated by Colin Smith, London: Routledge and Kegan. Originally published in French under the title: *Phénoménologie de la Perception,* Paris 1945, Éditions Gallimard.

Merleau-Ponty, Maurice 1968: *The Visible and the Invisible,* translated by Alphonso Lingis 1968, Northwestern University Press. Originally published in French under the title: *Le Visible et L'invisible,* Paris 1964, Éditions Gallimard.

Merleau-Ponty, Maurice 1964: *Signs,* translated by Richard C. McCleary, 1964, Northwestern University Press. Originally published in French under the title *Signes,* Paris 1960, Librairie Gallimard.

Olsen, Kasper Nefer 1933: *Labyrint - für freie Geister* [Labyrinth - for Free Spirits], Copenhagen: The Royal Danish Academy of Fine Arts.

Rasmussen, Michael 1992: *Hjelmslevs sprogteori* [The Language Theory of Hjelmslev] Odense University Press.

Reid, Norman (ed.) 1974: *Turner 1775-1851,* London: Tate Gallery Publications Department.

Saussure, Ferdinand de 1959: *Course in General Linguistics*, translated by Wade Baskin, N.Y.: McGraw-Hill Paperbacks. Originally published in French under the Title: *Cours de linguistique générale*, Paris 1916, Payot, Paris.

Serres, Michel 1983: "Markov og Babel - samtale med Michel Serres" [Markov and Babel - a conversation with Michel Serres], *Semiotik 5-6*, København: Edition Basilisk.

Serres, Michel 1985: *Les cinq sens - philosophie des corps mêlés - 1* [The five Senses - a philosophy of the mixed bodies], Paris: Bernard Grasset.

Serres, Michel 1990: "Lærred, klæde, hud" [Canvas, Cloth, Skin], in *Billedets onde ånd*, København: The Royal Danish Academy of Fine Arts.

Stjernfelt, Frederik 1992: *Formens betydning - Katastrofeteori og semiotik* [The Meaning of Form - Catastrophe Theory and Semiotics], Copenhagen: Akademisk Forlag.

Stjernfelt, Frederik (ed.) 1993: "Filosofiske implikationer af kognitiv semantik" [Philosophical implications of cognitive semantics], *Kritik nr. 102,* Copenhagen: Gyldendal.

Søndergaard, Morten 1993: *Tid og rum og Borges* [Time and Space and Borges], Copenhagen 1993, Special Dissertation on Department of Comparative Literature, University of Copenhagen.

Talmy, Leonard 1988: "Force dynamics in language and cognition", *Cognitive Science 12,* Berkeley. (The article is an updated and revised version of: "Force Dynamics in Language and Thought" in: W. Eilfort (ed.) *Papers from the parasession on Causatives and Agentivity at 21st Regional Meeting,* Chicago Linguistic Society, University of Chicago,1985).

Talmy, Leonard 1992: "How language structures its concepts: the role of Grammar", *unpublished handout*, State University of N.Y. at Buffalo.

Turner, J.M.W 1846: *The Angel standing in the Sun,* Oil on canvas, Tate Gallery. *See appendix.*

APPENDIX

Examples of a graphic representation of cusp equations:

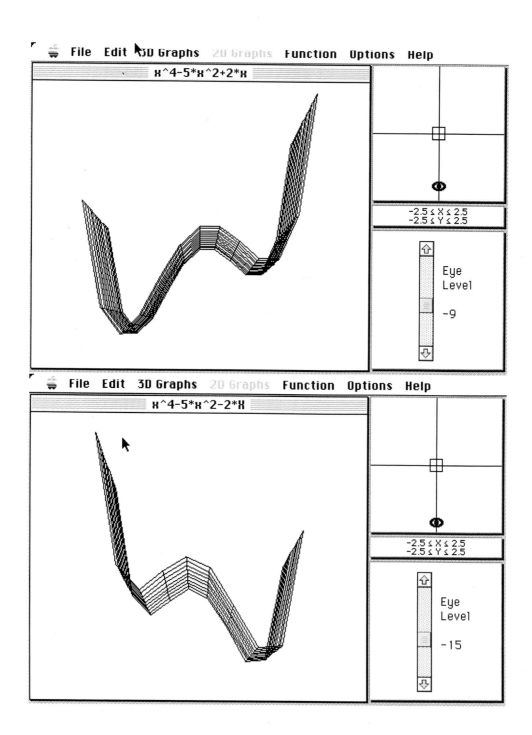

Søren Kierkegaard: "the Nook of the Eight Paths"

1 In Gribs-Skov there is a place called the Nook of the Eight Paths; only
the one who seeks worthily finds it, for no map indicates it. Indeed, the
name itself seems to contain a contradiction, for how can the meeting of
eight paths create a nook, how can the beaten and frequented be recon-
5 ciled with the out-of-the-way and the hidden? And, indeed, what the
solitary shuns is simply named after a meeting of three paths: triviality —
how trivial, then, must be a meeting of eight paths! And yet it is so: there
actually are eight paths, but nevertheless it is very solitary there. Out-of-
the-way, hidden, and secret — one is very close to a forest area called the
10 Unlucky Enclosure. Thus the contradiction in the name only makes the
place more solitary, just as contradiction always makes for solitariness.
The eight paths — heavy traffic is only a possibility, a possibility for
thought, because no one travels this path except a tiny insect that hurries
across *lente festinans*.[1] No one travels it except that fugitive traveler that is
15 constantly looking around, not in order to find someone but in order to
avoid everyone, that fugitive that even in its hiding place does not feel
the traveller's longing for a message from someone, that fugitive that only
the fatal bullet overtakes, which indeed explains why the deer now
became so still but does not explain why it was so restless. No one travels
20 this road except the wind, about which it is not known whence it comes
or whither it goes. Even he who let himself be deceived by that beguiling
beckoning with which the shut-in-ness tries to catch the wayfarer, even
he who followed the narrow footpath that lures one into the enclosures
of the forest, even he is not as solitary as someone at the eight paths that
25 no one travels. Eight paths and not a traveller! Indeed, it is as if the world
were dead and the one survivor were in the awkward situation that there
was no one to bury him, or as if the whole tribe had gone off on the
eight paths and had forgotten someone! — If what the poet says is true:
Bene vixit qui bene latuit,[2] then I have lived well, for my nook was well
30 chosen. It certainly is true that the world and everything therein never
look better than when seen from a nook and one must secretly contrive
to see it; it is also true that everything heard and to be heard in the world
sounds most delectable and enchanting heard from a nook when one
must contrive to hear. Thus I have frequently visited my sequestered
35 nook. I knew it before, long before; by now I have learned not to need
nighttime in order to find stillness, for here it is always still, always beau-
tiful, but it seems most beautiful to me now when the autumn sun is
having its midafternoon repast and the sky becomes a languorous blue
when creation takes a deep breath after the heat, when the cooling starts

1. hastening at leisure

2. He who has hidden well has lived well

40 and the meadow grass shivers voluptuously as the forest waves, when the
 sun is thinking of eventide and sinking into the ocean at eventide, when
 the earth is getting ready for rest and is thinking of giving thanks, when
 just before taking leave they have an understanding with one another in
 that tender melting together that darkens the forest and makes the mea-
45 dow greener.
 O friendly spirit, you who inhabit these places, thank you for always
 protecting my stillness, thank you for those hours spent in recollection's
 pursuits, thank you for that hiding place I call my own!

Thorkild Bjørnvig: "The Dune Mirror"

1 In a place far inside I found in a panic
 deathly still midday hour, where roots twisted
 like vipers and a viper looked like
 a stiffened black-brown root, a sand pothole, horizontal
5 countersunk in an old sombre heathery dune,
 hidden, only visible at the rim - and its emptiness,
 dazzlingly white and pure, touched me
 and drew my gaze in constant vertigo down
 to the bottom, to the empty cone's point,
10 its calm and heat-rustling, distance, fire,
 down - with the same force as the sky up:
 perhaps a cosmic mirror which captured everything
 and gave nothing back - than for the mind
 which scarcely saw, was but shaken by certainty
15 of baseless horror, of inexplicable rejoicing
 and felt what it partly saw as image
 incessantly erased by a contrary image
 that rose like a volatile haze from the mirror's bottom:
 a flower calyx fructified by azure
20 to fruition in a thousand years, a moon crater
 brimming with cold, fire, an abstraction,
 movement in an unmovingness,
 a first cause, final consequence, composition
 merely singing itself as silence sings -
25 needing no human, though striking
 in the one who listens, looks, a fundamental chord.
 Unchanged, sand trickles, slips, drifts
 in all weathers, day after day, unchanged
 into a single figure: a hanging poised in my blood
30 which the blood does not forget, regardless
 of whether I decay, am slowly broken down -
 a cornerstone to the world, placeless
 and all places possible, regardless -
 an eddy which becomes visible and gets power
35 when flesh and wood, metal and stone have crumbled,
 basic parts: the vortex's mask, expression, matter -

J. M. W. Turner: *The Angel standing in the Sun.* Oil on canvas (78, x 78.5 cm), Tate Gallery.

Arne Johnsson: "XII"

XII

1 February. It's the water bringer's month.
 I become
 a child. I stand at the bridge
 over the stream, the current keeps a narrow furrow
5 open, the water gleams like dark metal
 in the gray light, a thin
 vibrating membrane: I try to listen.
 But it's
 like when I far later, in a small white room,
10 try to coordinate my beloved's yell that I'm to leave
 with the high and a riff of Charlie Parker. A child
 screams from the meadows,
 it takes off like a bird, I
 spit in the water, the white dot disappears in
15 under the ice. The sky darkens,
 the water bringer
 lowers his amphora, fills it
 and empties over the world. The snow falls,
 it looks like stars

Edward Hopper (1882-1967): *Solitude #56*, 1944. Oil on canvas (81.3 x 127 cm). Private collection.

Simon Grotrian: "Inspiration"

1	Star shadows whirl across the sheets
	where deserts grow
	vaster than my mouth;
	necklaces of bedouins dance on my desk
5	quickstep with pupils of onyx
	which see nothing.
	It's night, and the ink flows
	through the sand, I try to save myself
	but hit the dromedaries
10	squelching with black footprints beneath my eyes.
	And my own shadow breaks
	like a cactus between the tents
	I turn in the storm against the windblown garbs
	white may they flutter over the crowds
15	dropped on the floor beneath my eyes
	which shall congeal like the others
	circular in a saucer of upturned brows
	when my plume is laid on the lids
	with the full weight of sleep
20	and a knot of snakes writhes with tails out their maws.
	I rest a little in oasis
	as the humps evaporate
	the caravan paces the sky
	and the sun warms roofs.
25	There are bright days, now and then
	the dark is there, first and last.